70-0042

W/P

9/14

Ruskin and Italy

Nineteenth-Century Studies

Juliet McMaster, Series Editor
University Professor
University of Alberta

Consulting Editor:
James Kincaid
Professor of English
University of Colorado, Boulder

Other Titles in This Series

Ruskin and Italy

by
Alexander Bradley

U·M·I Research Press

Ann Arbor / London

Copyright © 1987
Leslie John Alexander Bradley
All rights reserved

Produced and distributed by
UMI Research Press
an imprint of
University Microfilms Inc.
Ann Arbor, Michigan 48106

Library of Congress Cataloging in Publication Data

Bradley, Alexander, 1948–
 Ruskin and Italy.

 (Nineteenth-century studies)
 Bibliography: p.
 Includes index.
 1. Ruskin, John, 1819–1900—Knowledge—Italy.
2. Ruskin, John, 1819–1900—Journeys—Italy. 3. Authors,
English—19th century—Biography. 4. Critics—Great
Britain—Biography. 5. Artists—Great Britain—Biography.
6. Italy—Description and travel—1861–1900. 7. Italy
in literature. I. Title. II. Series: Nineteenth-
century studies (Ann Arbor, Mich.)
PR5267.I8B73 1987 828'.809 87-24376
ISBN 0-8357-1854-9 (alk. paper)

British Library CIP data is available.

For Neville Sheppard

Contents

Acknowledgments

I would like to pay particular thanks to Professor Michael Wolff and Professor Meredith Raymond, both of the English Department at the University of Massachusetts at Amherst, and to Professor Neal Shipley of the History Department. This project would not have been possible without their help.

The museums which have kindly allowed me to illustrate this book with works in their possession are acknowledged in the appropriate caption. But I would like to thank especially the unfailingly helpful staff of the Prints and Drawings departments of each of those institutions.

I am extremely grateful also to the Department of Manuscripts at the British Library, London, for their permission to quote from the unpublished correspondence between Ruskin and Rawdon Brown.

Preface

The work which follows is not a biography of Ruskin; nor is it a critical study of his writings. There are so many excellent examples of both already available that it would be hard to justify another of either. The aim of the present work is to follow a single biographical and thematic thread which will throw light simultaneously on the life and the writings. In Ruskin's case both *ars* and *vita* are long, complex and extremely dense in texture; the interested reader, even the interested reader with some background in the literature of the nineteenth century, needs guidance through the Ruskinian maze. The thirty-nine large volumes of the *Collected Works*, and the veritable library of secondary material, have daunted many a potential reader, bewildered by the overlappings and interlacings of apparently diverse works, often oddly named, produced over so many decades.

The thematic thread chosen here is Italy. It is merely one out of which the intricate pattern of Ruskin's career is woven; but it is, of course, the present author's belief that Italy is an especially useful and enlightening thread to follow, and that it, more than any other, leads to and reveals the greatest richness of biographical relevance and the most valuable insights into the works. Ruskin's experience in and of Italy permeate his entire life and career. The greater part of his published writings and his occasional lectures derives directly from his lifelong concern for the life and culture of Italy. It is in Italy that the great "crises" which focus and occasionally redirect his energies take place. Ruskin made Italy and things Italian—artists, buildings, whole cities—serve as a series of symbols, or types, moral and artistic, throughout his career.

What follows has two claims to the reader's attention. Firstly, it is based on an extensive reading of Ruskin's works and a broad familiarity with the secondary sources. In no other single study can one find a full and detailed description of all the Italian journeys, or a complete investigation of their importance on Ruskin's development. Some of the visits, of course, are granted an inevitable importance in any book on Ruskin—

especially the two long Venetian stays, out of which *The Stones of Venice* grew. Others, however, do not fare as well. In particular, the earlier visits, the second chapter of the present work, are often skimped or ignored altogether, and the researcher has to work much harder to establish the chronology and the major events of those journeys. Even the excellent recent biography by John Dixon Hunt, *The Wider Sea*, has little to say of these early visits. At the other end of the life, the later visits also tend to be slighted. They are often lumped together on the assumption that Ruskin's mental powers were by then so weakened that the works produced must therefore be of little value. But if one wishes to attain a sense of the fullness of Ruskin's achievement, one must follow his career through these later works, even if his character seems more troublesome and even if the books themselves strike us as less interesting. It is generally true that the works most readily dismissed by the modern reader were precisely those most popular and influential in Ruskin's own day.

The second contribution of the present study, involving research into unpublished primary sources, is of value only insofar as it contributes to this main effort, outlined above. Much of the correspondence between Ruskin and Rawdon Lubbock Brown, who figures largely in the fourth chapter, remains unpublished in the British Library. It is one of the subsidiary arguments of this work that Brown's importance in Ruskin's Italian writings has been consistently underestimated. It is quite easy to read a great deal of Ruskin secondary material and remain unaware of the significance of Rawdon Brown, or even of his existence. Of earlier studies, Mary Lutyens' *Effie in Venice* perhaps tells most of Brown, but, as her title suggests, she is more interested in Mrs. than in Mr. Ruskin, and she deals only with the two Venetian stays of 1849/50 and 1851/52 when Effie was present. As will be shown, Brown continues to play an important part in Ruskin's life after the period that produced *The Stones of Venice*. Jeanne Clegg's *Ruskin and Venice* is the only other existing work to make significant mention of Brown. Chapter 4 re-establishes Rawdon Brown in Ruskin's Italian biography, and an appendix offers the reader desirous of more detail a full sense of the correspondence between them.

Perhaps a Preface is the best place to establish a context with previous scholarship, focusing in particular upon the usefulness of earlier works for the subject of Ruskin and Italy. It is a commonplace of Ruskin studies that the first great watershed was the 1933 appearance of R. H. Wilenski's book. Wilenski was the first to attempt to "read" all of Ruskin's career and output in the light of a single unifying thesis, in this case a thesis concerning the nature of his mental problems. Without exception, all works before Wilenski fall into the category of "great man" memorials, usually written by the first generation of Ruskin followers and acolytes. E. T. Cook and W. G. Collingwood are the most famous. Such studies

can frequently be useful for dates, itineraries, first-hand anecdotes, and so forth; but they must inevitably seem unsophisticated after Wilenski, and all are marred by the predictable reticences of their period. If Wilenski ushered in a new era, a more complex Ruskin, the three studies by Joan Evans, Derrick Leon, and Peter Quennell, all written within a short time of one another around 1950, represent the major "synthetic" studies of the whole man, though each of them has his or her particular emphasis, Evans towards art, Leon towards politics and economics, and Quennell towards literary style. Perhaps J. D. Rosenberg's *The Darkening Glass* represents the next stage in the growth of an organic and entire view of Ruskin's work. The present study is indebted to all of the aforementioned works, insofar as it, too, attempts a total view of Ruskin's career and development. There is, of course, a wealth of more specialist studies on one particular aspect of Ruskin's output or life—Ruskin the economist, Ruskin the architectural historian, and so forth. These, whatever their more general merits, are not of specific relevance to the present study unless they illuminate the Italian story. Many of them do, in ways too numerous and repetitive to mention here; the presence of such a specialist book in the bibliography indicates such relevance. Among these books are two entitled *Ruskin and Venice*. The first is by Robert Hewison, and is, quite understandably, weighted heavily in favor of the two long stays in 1849/50 and 1851/52. Little is said of the earlier visits, or of the imaginative baggage Ruskin took with him on his first visit. Hewison's richly illustrated book, an expanded exhibition catalogue, is an excellent source of visual material. Jeanne Clegg's *Ruskin and Venice* is a more detailed account, though she, too, tends to skimp the earlier visits and concentrate on the production of *Stones*. It is no part of Clegg's intention to place the Venetian experience within the larger context of Ruskin's life and career. Published collections of letters have proved invaluable, especially the following: Van Akin Burd's *The Ruskin Family Letters*; Harold Shapiro's *Ruskin in Italy*, presenting the letters of the 1845 trip; J. L. Bradley's *Ruskin's Letters from Venice*, and John Hayman's *Letters from the Continent*, covering the 1858 visit to Turin. To these should be added the unpublished correspondence between Ruskin and Rawdon Brown in the British Library. The Evans/Whitehouse edition of the *Diaries* is indispensible, though, as Tim Hilton points out in his recent *John Ruskin: The Early Years*, even those three fat volumes are a small selection, and much original material remains unexplored. Finally, mention should be made of a handful of books not specifically on Ruskin, but which provide most helpful background for the Italian experience. Of these Kenneth Churchill's *Italy and English Literature* must top the list. Others include G. A. Treves' *The Golden Ring*, Olive Hamilton's *Paradise of Exiles*, and J. R. Hale's *Italian Journals of Samuel Rogers*.

Rogers' _Italy_

Few gifts to small boys who are later to become great men can have been quite so prophetic as the presentation, on the occasion of his thirteenth birthday, of a copy of Rogers' _Italy_ to John Ruskin, by Mr. Telford, his father's business partner. The history and the format of this remarkable book are of sufficient interest to warrant closer study, which should also make clear the importance of the gift to the youthful future author of so many studies of Italian life and culture.

The copy that Ruskin received on or near February 8, 1832, was from a revised and illustrated edition published in 1830.[1] But Rogers' _Italy_ had seen the light of day earlier, in 1822, when the first part had been published, at his own expense, by the banker poet. It had met with a resounding lack of success. A second part, appearing in 1828, fared only slightly better at the hands of the public, and Rogers eventually bought back and destroyed all unsold copies. Not one to be daunted, he reissued both parts together in 1830, and this time the work's success was as dramatic as its earlier failure. Why the publishing disasters of 1822 and 1828 should have become the rage of 1830 is a curious question. Perhaps the reading public, or that part of it comprising the newly enriched industrial middle-classes, thinking for the first time of foreign travel now that the turmoil of the Napoleonic era was comfortably over, was ready for a book to whet its growing appetite for what lay south of the Alps. Such changing social conditions may provide part of the answer. But the chief reason was surely Rogers' own stroke of genius in commissioning two of the very best topographical artists of the day, Turner and Stothard, to provide illustrations. This immediately gave his work a wider and more obvious appeal. Rogers says in his author's preface that the "embellishments" need no praise from him: "The two Artists, who have contributed so much to give it a value, would have done honour to any age or country."[2] The 1830 _Italy_ contains forty-nine engravings, of which twenty-five are after Turner, twenty after Stothard, and one each after pictures by Samuel Prout, Titian, Vasari, and Col. Batty. Most of these

"embellishments" take the form of a vignette, either at the beginning or at the end, sometimes both, of each of the work's descriptive sections.

Rogers' *Italy* takes its place among those semi-fictionalized travelogs, sometimes in poetry, sometimes in prose, that are the precursors of the later guidebooks. Earlier examples, to which Rogers was indebted, include Thomas Nugent's *The Grand Tour* (1747), John Northall's *Travels through Italy* (1766) and the *View of Society and Manners in Italy* (1781) by Dr. John Moore, later famous for the Italian novel *Zeluco*. A subsequent shift of taste saw a change from fictional-travelog to travelog-fiction, of which Mme. de Staël's *Corinne* (1807) is the prime example, the fairly simple plot being an excuse for elaborate set-pieces describing the beauties of Italy. The enormous popularity of that work encouraged copious imitation; as late as Hawthorne's *Marble Faun* (1860) the genre is still to be found.

Such books, in Rogers' day, were usually the handiwork of the wealthy or aristocratic who were privileged to take the Tour, sometimes of a member of their equipage. Their value was quite practical and immediate in an age before the guidebook, which came into its own only when the middle-classes began to travel in large numbers, by mid-century. Those who took the Grand Tour were accompanied by guides, not guidebooks. Ruskin's own career spans, and partly causes, this shift. In his early travels he often had a "courier" or guide, such as Couttet in Switzerland; during his later travels he occasionally contributed material to the earliest of the guidebooks, including *Murray's Handbook to Northern Italy* (1847), and by the end of his travelling life his own works were being adapted and used as guidebooks by the very middle-classes whose presence in foreign parts he so deplored. But in the early century these personal, often idiosyncratic, accounts of a gentleman's travels were all that was available to the reading public interested in distant places. They contained little, and no doubt were expected to contain little, of definite and reliable practical information in the Baedeker sense, but they offered amusement, the companionship of a cultivated sensibility, and, for the non-traveller, the vicarious thrill of the unknown and the picturesque.

Just such a book was *Italy*. Rogers' family was not noble, and was only recently rich. His grandfather had made a fortune with a glass-works, on the proceeds of which his father founded a bank, on the proceeds of which Samuel Rogers made himself into one of the great gentleman-connoisseurs and social lions of his day. As soon as the cessation of Napoleonic hostilities permitted, in 1814, he set out for France and Italy. His *Italy*, he tells us, is generally a record of his travels "as it was written on the spot."[3] But the cautious reader should be aware, in the light of this somewhat bland statement, that the work is quite varied. Though

many of the sections of *Italy*, most of which, incidentally, are written in blank verse, some in prose, are fairly straightforward topographical descriptions of particular Italian sites noted for their natural beauty, other sections are quite different. Several are concerned exclusively with literary or historical association, which constituted much of the interest in remote places for the eighteenth- as for the nineteenth-century sensibility. Others again are more plainly anecdotal in a novelistic way—small character studies or short, piquant tales—"A Harper," "The Nun," "A Funeral," and so on. These are generally taken, says Rogers, "from the old chroniclers," and they are clearly meant to appeal to the taste of the age for picturesque incident and colorful characters by the wayside. One thinks how similar and contemporary creations in Goethe's *Wilhelm Meister* fired the imagination of Europe. It is essentially the same taste as that which craved ornamental hermits, read Mrs. Radcliffe's novels, and thrilled to the debonair banditti of Salvator Rosa.[4]

Enough has been said about Rogers and his *Italy* to suggest that, before turning in the next chapter to Ruskin's own southern travels, it might be useful to place Roger's poem in fuller context and, at the same time, to examine the other formative literary experiences which helped to shape Ruskin's view of Italy before he actually went there.

In the century or so before Ruskin it is possible to distinguish three separate stages in the English literary response to Italy. Ruskin, perhaps, when his time came, initiated a fourth. There is, firstly, the eighteenth-century rationalist view of Italy, typified by Addison in his *Letter from Italy* (1701), and culminating in the monumental work of Gibbon, inspired by his one and only year in Italy, 1764/65. This is the Italy of the Grand Tour. Only the classical past is esteemed, tailoring experience to suit the mental equipment of the classically educated gentleman making the journey. The Italy of their own day is despised on all counts, and modern Italians are the slavish and degenerate *epigoni* of a race of heroes. Catholicism is, of course, the basest idolatry and superstition. It had to be believed, in order to maintain this arrogant stance, that the mantle of empire had passed to England, and that the gentleman-travellers themselves were therefore the true inheritors of Rome. Non-classical Italy is hardly noticed, and if noticed, rejected. Gibbon's intemperate dislike of Venice is well known.

Secondly, towards the end of the eighteenth century, visions of Italy and Italians were called into the service of the sensational and mysterious. The "Gothick" novel, beginning with Walpole's *The Castle of Otranto* (1764), found in Italy the ideal hunting-ground for passion, intrigue and suspense. There is a town of Otranto in Italy, but much farther south than Walpole ever ventured; it was, presumably, the romance and remote-

ness of the name that attracted him. The highly lucrative formula of Mrs. Radcliffe depended equally on Italian scenes she had never visited.[5] Dr. John Moore's *Zeluco* (1789) was just as popular and was much admired by Byron. This is the Italy of Machiavellian counts in their Apennine retreats, lovelorn maidens incarcerated in sadistic nunneries, of extravagant and passionate bandits, living by the serenade and the stiletto, who always turn out in the end to be of noble birth.

Thirdly, and it is here that we must place Rogers' *Italy*, there developed a more sophisticated "romantic" Italy, blending a wider and more intelligent appreciation for its color and atmosphere with nostalgia for its vanished glories, and a sense of the dramatic interplay between northern and southern values and mores. It may have been Mme. de Staël's *Corinne* which initiated this phase, and perhaps the late novels of Henry James which bring it to its last and most spectacular flowering.

Both Wordsworth and Coleridge knew Italy. Wordsworth's ode "On the Extinction of the Venetian Republic" was composed in 1802. Book VI of the *Prelude* takes place in part in the Italian Lakes. Coleridge is one of the first known admirers of the frescoes in the Campo Santo at Pisa, later so dear to Ruskin. Byron settled in Italy in 1816 and stayed there until leaving for Greece in 1823. With him romantic Italy becomes a very serious matter. In Byron's works Italy is no longer a series of pantomime sets against which to display stock characters, cardboard Italians; rather, his Italy has become a living symbol, its places and its personae fused with the subjective states of the poet. Childe Harold goes to Italy to be "a ruin amidst ruins" (IV, 25). The "decay" of Italy is no longer merely a source of picturesque delight, but a metaphor for the poet himself. It will be seen later how Ruskin, devotedly Byronic in his early days, could project onto Italy his own inner conflicts and strivings. Byron's chief Italian productions, all beloved by Ruskin, were his "Ode on Venice" (1818), "Beppo" (1818), and the two Venetian tragedies, "Marino Faliero" (1821), and "The Two Foscari" (1821).

Shelley, too, lived in Italy, and, like Keats, died there. It was he who coined the phrase "Paradise of exiles" to describe Italy in "Julian and Maddalo." Both Byron and Shelley, in sharp contrast to their eighteenth-century precursors, adored Venice, preferring it to "classical" Italy. Disraeli travelled south of the Alps in 1826, brimming with Byronic enthusiasm—he even made a point of visiting the poet's old boatman. He, too, was drawn towards Venice rather than Florence or Rome. *Contarini Fleming* (1832) overflows with Byronic *weltschmerz*; in 1837 both *Henrietta Temple* and *Venetia* appeared. Finally, one should not overlook Bulwer-Lytton's two highly popular novels on Italian themes, *The Last Days of Pompeii* (1834) and *Rienzi* (1835).

Such, briefly, was the presentation and representation of Italy in English literature before Ruskin, the stuff of his youthful notions of the country. To it one need only add Shakespeare and the Jacobean dramatists to complete the picture. Not surprisingly, the eighteenth-century travellers thought little of Shakespeare's Italian settings, but by the time of the romantics references abound to "Othello," "Romeo and Juliet," and "The Two Gentlemen of Verona." Byron proudly chipped off souvenir pieces from Juliet's tomb, to send home to friends and relatives.

The young Ruskin, very much in reaction to the detested Gibbon,[6] modelled his early literary effusions on his romantic heroes. Among his juvenilia are to be found "Leoni: A Legend of Italy," a story infused with the spirit of Mrs. Radcliffe and Salvator Rosa, and a Byronesque Venetian drama, "Marcolini," taken from Rogers' tale of a young Venetian nobleman executed for a crime he did not commit. Ruskin was of the opinion that Bulwer-Lytton's *The Last Days of Pompeii* gave its readers "a clearer idea of the manners prevailing at that period than they ever obtained from their classical studies."[7] In *Praeterita* he wrote "my Venice, like Turner's, had been chiefly created for us by Byron,"[8] and of Byron, "He taught me the meaning of Chillon and Meillerie, and bade me first seek in Venice . . . the ruined homes of Foscari and Falier."[9] Later, predictably enough, a more sober and scientific Ruskin was a little embarrassed by his youthful romantic enthusiasms, and was anxious to temper them. He wrote to his father, "The Venice of modern fiction and drama is a thing of yesterday . . . a stage dream which the first ray of daylight must dissipate into dust."[10] And, indeed, Ruskin can be seen as initiating a fourth stage in the English literary conception of Italy, reacting, as did Browning at the same time, against the earlier romantic excesses in favor of a more thorough scholarship and greater historical understanding.[11] Yet he is still able to write in *Praeterita*, of Rogers' *Italy*, "I might, not without some appearance of reason, attribute to the gift the entire direction of my life's energies."[12]

The two great passions of the first half of Ruskin's life, Turner and Italy, were brought together in Rogers' poem. They were wedded in his mind, not inappropriately, for Turner himself had a great love of Italy, particularly Venice. He first visited that city in 1819, the year of Ruskin's birth, and returned there in 1832, 1835, and 1840. In addition to the vignettes for *Italy*, Turner painted a large number of views of Venice in oil and watercolor. In 1830 he produced a set of illustrations for Byron's Italian poems.

The year after the receipt of this marvellous gift, if Ruskin is right in his chronology (and he admits to some doubt), he took the first of his foreign tours to include Italy, and the first of any kind of which he claimed

significant recollection. Little remained with him of the trip he had taken, aged five, to Paris with his parents who wanted to see the coronation of Charles X. He says they spent "several weeks" in Paris and a few days in Brussels.[13] So it was with a head filled with Rogers and Byron, determined to become a great artist in the manner of Turner, that the fourteen-year-old John Ruskin set off with his parents on a tour of the Continent.

The First Three Visits

The three trips to Italy that Ruskin took as a youth, in 1833, 1835, and 1840, always in the company of his parents, can usefully be grouped together. This is not to imply that the three journeys were merely repetitive—they differed in purpose as well as in itinerary—but all are preparatory to Ruskin's first visit without his family, in 1845 at the age of twenty-six. These early journeys provided the basic familiarity that made the more profound discoveries of 1845 possible.

It was, apparently, despite her image as the dourly unimaginative old Calvinist projected in most biographies, Ruskin's mother who first had the initiative to suggest, seeing father and son poring over such publications as Rogers' *Italy* and Prout's *Sketches in Flanders and Germany*, that they might all go off and see these wonderful places for themselves. In a sense she missed the point. She assumed that if mere pictures of these places interested her son so greatly, then how much more would the places themselves. For her aesthete son the emphasis was always the other way round. He saw Europe through the eyes of his favorite artists, transmuting through art each building or each mountainside into a thing of moral significance.

At the beginning of May 1833, they set out to see the sights depicted in their treasured folio volumes, going down the Rhine in honor of Prout, over the Alps and into Italy for Rogers and Turner. Ruskin has described the "two or three weeks of entirely rapturous and amazed preparation."[1] during which he swotted up on the Alps from his school geography texts. The party consisted of the three Ruskins, an orphaned cousin named Mary Richardson, and Anne, an old family nurse. They disembarked at Calais on May 11.

It is fair to say that Switzerland in general and the Alps in particular were more eagerly anticipated objects of this journey than was Italy. The Rhine and the Alps were more vividly impressed on Ruskin's mind by recent studies, geology especially. Despite this, it is clear that the thought of the land of Italy already had considerable sway over his imagination,

as the following quotation shows. The young Ruskin was finding north-eastern France and Belgium somewhat dull—as indeed the older Ruskin was always to do—and his highest praise, in the travel diary for this journey, was to call a certain day "almost Italian, the sky was of such deep and unbroken blue."[2] Ruskin was, of course, on his way to Italy for the first time in his life.

They crossed over the Splügen Pass, "the grandest pass into Italy";[3] the first valley of the main Alps, the Via Mala, being Ruskin's introductory contact with Italian soil. They stayed first at Cadenabbia, then crossed the lake to Como itself. In keeping with this mountainous itinerary, Ruskin's diary entries at this time are entirely scientific and geological. He had with him, precocious teenager, a cyanometer, an instrument for measuring the degree of blueness of the sky. Throughout his life Ruskin was a tireless collector and examiner of rocks and stones. There is no evidence at this point of any interest in architecture, nor indeed in much of anything man-made. His first publications were geological papers for Loudon's *Magazine of Natural History*.[4] His requested birthday present for 1834, successor to Rogers' *Italy*, was the very much more scientific Saussure's *Voyages dans les Alpes*.

His only artistic passion in 1833 was his devotion to the sketches of Turner and Prout. He drew furiously, seeking to imitate the achievements of these heroes. His vision was theirs.[5] Lake Como was seen, according to E. T. Cook, Ruskin's editor and one of his earliest biographers, "through Turner's eyes from memories of the vignettes in Rogers' *Italy*."[6] One wonders how accurate is the word "memories" in this case. It is hard to imagine the Ruskin family, earnest and industrious travellers, always eager for improvement and edification, and given their known fondness for Rogers, not carrying this volume, or any other that might prove useful, in their copious luggage. Of this stay in Como Ruskin himself later wrote, "the artificial taste in me had been mainly formed by Turner's rendering of those very scenes in Rogers' *Italy*. The 'Lake of Como,' the two moonlight villas, and the 'Farewell' had prepared me for all that was beautiful and right in the terraced gardens, proportioned arcades, and white spaces of sunny wall."[7] He refers here, of course, to the famous Borromeo Gardens, and adds, wryly, that at this time he was unaware of the evils and decadence of the Renaissance and all its works, so that at the tender age of fourteen he knew no better than to enjoy the whole thing. In similar vein, later on the same tour, he says that the Cathedral of Milan was "a consummate rapture to me, not having yet the taste to discern good Gothic from bad."

After Como the party travelled by way of Monza to Milan, and then to Genoa,[8] intending, so Ruskin avows, to press on as far south as Rome, "but, it being June already, the heat of Genoa warned us of imprudence."[9]

So they turned back to Geneva, then, through Chamonix—later to become, with Venice, one of Ruskin's two "bournes of earth"—to France and home. France received very little notice on the homeward journey, and Paris did not hold them. It may be that the elder Ruskins felt that they had seen quite enough of Paris, one way or another, in 1824. But one wonders how much curiosity their son might have had. One wonders, too, how important were the picture galleries of Europe to the Ruskins at this time, and how much exposure to them the fourteen-year-old John had. Clearly the Louvre sang no siren song for their ears. Did they visit the galleries in Milan, already among the finest in Europe, or those in Genoa?

Ruskin voiced some retrospective complaint in *Praeterita* over their means of travel during this journey, by post-horse. This system, to which there was then no alternative, required careful planning of time if one were to cover the standard forty to fifty miles per day, not including Sundays, when the strictly sabbatarian Ruskins did not budge. As a result of this, he says, his father would become nervous early in the day and anxious to secure their resting place for the coming night. Accordingly, he would never allow their pace to slacken, nor set aside time for his son to stop and sketch. So Ruskin developed the habit, which he later considered a bad one, of making rapid scrawls as the carriage went along, and "working them up" later in the evening. Joan Evans, writing of this first tour, describes the young Ruskin sketching "pseudo-Turner vignettes."[10] This is Ruskin's own verdict on the drawings he produced during this journey: "for the most part one just like another, and without exception stupid and characterless to the last degree."[11]

Another problem of travel which emerges clearly from the diaries was the feeling of enslavement to their various couriers. No doubt this was an inescapable consequence of the inflexible post-horse system, especially for inexperienced travellers unfamiliar with their entire route, apparently speaking no foreign language beyond a very little French, and without even the reassurance of a guidebook. Ruskin, though his more usual habit is to denigrate the present from which he writes by contrasting it to a lost golden age, almost seems to sigh with regret when he tells us, "Murray did not exist in those days."[12]

The Ruskins, no doubt in common with most middle-class English travellers of their period, insulated themselves as thoroughly as possible from all foreign manners and persons, exchanging no conversation with fellow travellers or guests at the inns where they stayed. In light of their above-mentioned limitations this attitude may not appear surprising, but it remains largely true of Ruskin throughout his extensive adult experience of travelling and living in Italy. Always his close friends were other

Englishmen or Americans, not Italians. Some of the reasons for this hermetic insularity should emerge later.

Ruthlessly self-critical and stripped of all illusion as Ruskin could certainly be, when he came to write *Praeterita* he remembered this first journey abroad with great fondness, feeling that he had enjoyed "more passionate happiness . . . in those three months, than most people have in all their lives."[13] Upon the family's return he embarked on a lengthy descriptive poem based upon their travels, as he had done earlier with a journey through the English Lakes, the "Iteriad," which was to be decorated with vignettes taken from those on-the-road sketches already mentioned, the whole thing, he says, to be "in imitation of Rogers' *Italy*."[14]

The general purpose and emphasis of the tour the Ruskins took in 1835 resembled those of the earlier journey. They were in search of edification and the picturesque. Switzerland once again loomed as large in their plans as Italy. Most of Ruskin's preparations and ambitions are familiar from two years before. He again kept a travel journal; he intended once more to write a topographical descriptive poem with his own illustrations; he took along his trusty cyanometer and a special ruled notebook for geological observations. The diary for this tour is a rather dull and factual thing. Its most interesting features are the small pen and ink sketches, generally of rock formations. Few of the entries provide any picturesque description of the sort for which Ruskin was shortly to become famous. More usually they record cyanometer readings and other such data. But one must remember, lest all this seem thoroughly sterile, that Ruskin's first essays in print emerged from these dry observations. And readers of *Modern Painters* will not need to be reminded that almost as much space in those five volumes is given to geology as is given to painters, ancient or modern. For Ruskin, all visual experience, natural or man-made, was one. To deal with the more imaginative side of this tour, as if he consciously strove to keep art and science quite separate, Ruskin planned to compose a descriptive poem "in the style of 'Don Juan' artfully combined with that of 'Childe Harold.' "[15] Only two cantos were completed before the project was abandoned. There would seem to be little enough of Byron about these fragments beyond a few improbable rhymes, such as "wind they go" and "indigo," "Tom Becket is" and "antiquities."

There was, however, one very important addition to Ruskin's baggage at this time. He took along, a thing he did not have with him in 1833, "a large quarto for architectural sketches, with square rule and foot rule ingeniously fastened outside."[16]

Though strictly beyond the scope of the present work, it may be relevant, in connection with this architectural sketchbook, to notice that

several French sites, especially his later-beloved Abbeville, received far more attention than they had previously. He paid his first visit to Rouen, which later, when in *Praeterita* he gave order and pattern to the past, he calls one of the "three centres of my life's thought."[17] Even though he admits that the full power and significance of these towns was not yet to be completely realised, still one can see the incipient, instinctive passion for Gothic architecture beginning to assert itself.

Another noteworthy shift is that Ruskin, in describing the sights and events of this journey, began in these notebooks to use the first person singular. He now wrote of *his* discoveries, *his* first mountain views, though, as in 1833, he was travelling with his parents and his cousin Mary. Anne, the old nurse, no longer seems to have been with them.

The party left on June 2, 1835, and returned on December 10. They moved rapidly through France to the Swiss Alps, where Ruskin did much walking and much sketching. *Praeterita*, this time, has little to say of the Italian part of the trip. Ruskin breaks off, having sung the glories of the Alps, promising to return later to the narrative of this journey. Typically, lured on by that will-o'-the-wisp allusiveness peculiarly his, he never does. Most significantly, in terms of Ruskin's Italian experience, this is the trip that first took him to Venice. They spent six days there. The autobiography contains one or two fairly oblique references to the initial impact the city had on him. He hatched the intention, partially realised, while in the throes of his infatuation for Adèle Domecq, daughter of one of his father's colleagues, and while "in a state of majestic imbecility, to write a tragedy on a Venetian subject, in which the sorrows of my soul were to be enshrined in immortal verse."[18] "Marcolini," the product of these impulses, has already been referred to in the first chapter. Another project, equally ambitious, was his announcement to his parents "that I meant to make such a drawing of the Ducal Palace as never had been made before." Trivial and grandiose as both of these ventures may sound, Ruskin admits that his foolish and abortive tragedy, in which he worked his way through the ghosts of Shakespeare, Byron and Adèle Domecq, taught him a great deal about writing in general and about writing poetry in particular. Within a very few years, it should be remembered, Ruskin was to win the Newdigate Poetry Prize at Oxford. As for the drawing, disparage it as Ruskin might for its juvenility and technical clumsiness, it was the earliest recorded example in a long and glorious series of drawings of Venetian architecture, which did indeed show the city as it never had been shown before.

That the young Ruskin was amply primed by art and literature for the "correct" response to Venice is further proved by an unpublished manuscript intended as a prefatory sketch for *St. Mark's Rest*. In it, incidentally, he incorrectly dates his first Venetian visit as 1833:

I knew the Two Gentlemen, the Merchants of Verona and Venice, better than any gentlemen or merchants in London, and had learned most of Romeo and Juliet by heart; and all the beautiful beginnings of Othello. From Byron, though with less reverence, I had received even deeper impressions. . . . Add to them Rogers' poems, with Turner vignettes—and Shelley's "Julian and Maddalo," Prout drawings in the Watercolour Room of the Old Society and the list of my first tutors in Venetian work will be full.[19]

Once again the Ruskins were destined not to penetrate farther south into Italy. They planned to go to Rome, but just as excessive heat had prevented them two years earlier, this time a reported outbreak of cholera kept them away.

By the time of his third visit to Italy, in 1840, Ruskin was twenty-one and had spent three years at Oxford. The party consisted, as before, of his parents and cousin Mary, but his parents' motives for pressing this journey were somewhat different. Ruskin had been strongly advised to travel by his doctors, in particular to winter abroad for the coming year. As is usual in such cases, it is hard for the present-day observer looking back to tell what exactly was wrong, or to separate the physical from the psychological. Contemporary references offer such a variety of possible ailments that the Ruskin student can take his pick, from what the Victorians liked to call "nerves," perhaps brought on by his thwarted passion for Adèle Domecq, to incipient phthisis. It does seem, from mentions of occasional blood-coughing episodes, that something may well have been wrong with Ruskin's lungs. On the other hand, the manner of his "cure," as we shall shortly see, is such as to suggest a psychosomatic diagnosis. Whatever the truth of it, his parents were badly worried and decided to take their son abroad for the entire winter, the longest journey they had so far contemplated, lasting some ten months. They set off on September 24, 1840, and returned on June 29, 1841.

This rest-cure tour, in addition to any benefits it might have brought to Ruskin's lungs, greatly increased his knowledge of Italy, partly because it was much longer than the previous visits, partly because he was older and better prepared, and partly because they at last succeeded in venturing south, encountering a greater variety of scene and culture than ever before. He saw the quarries of Carrara for the first time, and penned a poem, "The Hills of Carrara."[20] This time in Genoa he saw Michelangelo's circular "Pietà," which he called "my initiation in all Italian art,"[21] perhaps indicating that the family had not been active in visiting galleries on their earlier tours. His interests by now clearly include architecture, and he was much impressed by his first sight of Lucca and Pisa, both towns later to become central to his studies in architectural

history. He took an immediate dislike, however, to Florence and Siena, first voicing that instinctive distrust of all things Renaissance which later grew into a crusade.

The journey from Florence to Rome took four days, with stops at Siena, Radicofani, and Viterbo. The Cathedral of Siena seemed to Ruskin "every way absurd—over-cut, over-striped, over-crocketed, over-gabled, a piece of costly confectionery, and faithless vanity."[22] Arriving in Rome on November 28, they stayed, as was almost obligatory for traditional English travellers, in the Piazza di Spagna. The Eternal City, not surprisingly and quite consistently, came off even worse than did Florence and Siena. Added to the growing dislike of Renaissance architecture there was now the extra goad of Roman Catholicism. And if this were not all quite enough, Ruskin, according to his first biographer, W. G. Collingwood, "took the fever" upon arrival in Rome, thus spoiling the rest of his stay there.[23]

Ruskin at the age of twenty-one was possessed of an enormous evangelical prejudice against the Catholic Church—though probably not one unusual for his class and period. He dismissed, with only a slight twinge of guilt stemming from the knowledge that Sir Joshua Reynolds liked them, Raphael's Stanze as "a mixture of Paganism and Papacy wholly inconsistent with the religious instruction I had received in Walworth."[24] It seemed not to occur to him as yet that the deficiency might conceivably lie with Walworth. The Roman Forum struck him as "the kind of thing that one is sick to death of in 'compositions,'"[25] quite an ironic turn for the young man who had earlier so unashamedly viewed Como and the Alps through the eyes of Turner. The Capitol is described as "a filthy, melancholy-looking, rubbishy place,"[26] and throughout Rome generally he finds "a strange horror lying over the whole city."

Certain biographers have seen in these negative and frequently bleak remarks evidence of that depression which, growing ever stronger in circular surges, was ultimately to make Ruskin mad.[27] This may be so. However, it is possible to attribute Ruskin's dark mood to smaller and more specific causes. Besides his poor physical health and the Domecq affair already mentioned, there was the realization that, being now twenty-one, he must soon choose a profession, and already he was feeling a great reluctance to follow the church career his family intended for him. But for what else was he suited? For the career he eventually made for himself there was then no name. Moreover, there is nothing in his strictures on Florence or Rome, violent and black as they may sometimes appear, that is not fully consistent with his lifelong tastes and prejudices. The tone of his remarks may seem bigoted and unduly self-assured in a twenty-one-year-old; but if so, Ruskin was equally self-assured at sixty-

one. In fact, in *Praeterita* there is a passage in which he congratulates himself, in 1882, that his quickly formed judgments of 1840 with regard to Raphael and others still seemed to him substantially right.[28] Nor should we forget that during the same journey he was just as capable of being adamantly cocksure in his praises as in his condemnations, as with Pisa and Lucca.

Some important social introductions while in Rome did something to compensate for Ruskin's utter disappointment in the city's art and architecture. From Oxford, Henry Acland had given him letters of introduction to Joseph Severn and George Richmond, both friendships which lasted, though Ruskin appears to have thought more highly of Richmond than of Severn, whom he always said had "something cockney about him." One is reminded of the early periodical attacks upon Keats, Severn's friend, as the representative of a "Cockney School." Ruskin's tastes in art must have seemed jarringly eccentric to these older men, formed as they themselves were on the Reynoldsian High Renaissance canon, whose gods were the very artists Ruskin despised. Another introduction made during this Roman winter was to Miss Tollemache, later, as Mrs. Cowper-Temple, to become one of the most important correspondents of his middle years.

By January 9, 1841, the Ruskins were in Naples, where the traditional ascent of Vesuvius was made, but where the dusty blackness of the volcanic soil displeased and depressed Ruskin, and where, perhaps, the sulphurous vapors caused a relapse to his ailing chest. They stayed there until March 17 and then returned to Rome. By April 18 they were in Bologna, and by May 6 in Venice, where they stayed for eleven days. Interestingly, for a family of self-improving "nouveaux riches," they had followed exactly the route of the classical aristocratic Grand Tour—down the Riviera to Genoa, to Lucca, Pisa, Florence, and Siena; then to Rome and Naples, north to Venice, leaving Italy by way of Milan and the Lakes.

Ruskin has left a full and vivid account of how his spirits rose as he approached Venice, now on his second visit after an interval of almost six years. In this autobiographical passage he begins to explore the source of Venice's overwhelming appeal for him, and perhaps also for others who have fallen captive to this unique city. He suggests it is the fusion of the very greatest natural beauty with the finest productions of the hand of man: "actual marble walls rising out of the salt sea, with hosts of little brown crabs on them, and Titians inside."[29] This charming conceit contains not only the essence of Venice, but surely, too, the essence of Ruskin's genius—the extraordinarily vivid and immediate perception of natural and man-made beauty; the dependency of the one upon the other; and their fusion in his searingly clear vision. His interest in the city's

architecture had by this time grown considerably, and during May he produced two important drawings, one of the Ca' Contarini Fasan, and another of the Giant's Staircase in the Ducal Palace. Venice had become "the Paradise of cities."[30]

It might be salutary at this point, after several quotations from *Praeterita*, to remind oneself that Ruskin's autobiography is an extremely artful recreation of the past, undoubtedly of the highest value as a spiritual record, a masterpiece of literary style, but not necessarily reliable on specifics or chronology. The contrast between the gloom of Rome and the glory of Venice was certainly heightened in retrospect, in order to serve the symbolic ends of the older writer. The truth is that for all of 1840 Ruskin's mood was weary and distraught. Most of what he saw failed to excite him. One can look for specific causes of unease, some of which have already been suggested, or else one can see, running through Ruskin's entire life, an extreme restlessness, an inability to settle with any satisfaction upon what is presently offered and available. Ruskin needed his "two bournes of earth," Venice and Chamonix, so that when in one he could dream of the other. Ruskin had a driving desire to be elsewhere always, a fact that must be faced in any work concerning his travels. Even his most beloved haunts could never hold him for long. It is remarkable how much of Ruskin's life was spent in transit. In addition to the numerous and extensive Italian journeys here being chronicled, there are many other European tours involving Switzerland and northern France, and two to Germany. Even when he was in England he was incessantly on the road, to Scotland or the Lake District. He never had a fixed home of his own until after the death of his parents, when in 1872 he bought Brantwood. Even then he continued to travel constantly, or else was at Oxford. Only insanity eventually held him still.

It is clear that many profound changes were taking place within Ruskin during this winter abroad. In retrospect it is possible to see that the effect of Rome, though it might appear at first sight entirely negative, in fact brought about two realizations quite crucial to his future development. Firstly, perhaps because for the first time in his life he had moved extensively within a large artistic colony, Ruskin understood that he did not have it in him to become a great artist. From this time on his drawings became "sketches" and "studies," illustrative aids to some larger purpose, making no attempt to rival the finish and presentation of the professional artist. This change of direction, this shift in technique, greatly distressed his father. At the same time, and quite possibly connected with some sense of disillusionment over his artistic capabilities, the travel diaries became less matter-of-fact, and began to feature more word-pictures, verbal evocations, the ancestors of such famous set-pieces as

the purpled depiction of the facade of St. Mark's in *The Stones of Venice*. Art was clearly to be his life's work, but not as a practising artist. Instead, Ruskin began to formulate his true vocation, to reveal and interpret beauty as critic and author. It was an adaptation of his parents' ecclesiastical ambitions for him; he was still to preach, but with art as his gospel and the press as his pulpit.

It is only in the light of such inner upheavals and self-discoveries that one can make sense of the great scene, so movingly described in *Praeterita*,[31] in Lanslebourg, on the French side of the Mt. Cenis Pass. After the black moods and anxiety that followed him through most of Italy, the concern for his future, his craving for a sense of "mission," Ruskin, on the verge of a breakdown, came to himself and a sense of his own destiny:

> I had found my life again—all the best of it. What good of religion, love, admiration or hope, had ever been taught to me, or felt by my best nature, rekindled at once; and my line of work, both by my own will and the aid granted to it by fate in the future, determined for me. I went down thankfully to my father and mother and told them I was sure I should get well.

This was the most important thing that Ruskin took away with him from all those months in Italy.

Alone at Last

Between the eventful finale of the last tour and the first he took without his parents, in 1845, Ruskin set foot on Italian soil only once, and that so briefly as not to be worthy of inclusion in the present study. In 1844 the family spent some weeks at Chamonix, during which time Ruskin took a one-day excursion to Lake Maggiore to see a Poussin in the hands of a private collector. More importantly, during this interval his first major publication had appeared, volume one of *Modern Painters*. The occasion of this work, as is well known, was an intemperate attack upon Turner by a prominent art critic. Ruskin immediately planned a defense and a justification of his hero. Already by his mid-twenties Ruskin had become a noted collector of Turner's works. Beginning with drawings and water-colors, particularly the topographical views from *Picturesque Views in England and Wales*, Ruskin soon started to acquire important oils.[1] There is a section in *Praeterita*[2] describing the Turners in the breakfast-room at Denmark Hill as they were in 1845. By this time Ruskin was the owner of the famous "Slave-ship." As Turner's executor, after 1851, Ruskin obtained many more examples of the master's work, most of which he eventually left to the Ashmolean Museum.

However, by the time the second volume of *Modern Painters* was published, 1846, the focus of Ruskin's attention had shifted from Turner to Italian painting. The reasons for this shift are to be sought in the experiences and discoveries of the 1845 trip to Italy. If the visit of 1840 had provided, through personal crisis, the realization of what was to be the proper direction of his energies, it is now, five years later, that the journey is truly undertaken. The next fifteen years of Ruskin's creative output grow out of the wealth of insights and ideas gathered in Italy in 1845.

Ruskin left London on April 2 for seven months, for the first time without his parents. Great was the anxiety of the marsupial-like elder Ruskins. He was initially accompanied only by a single servant, John Hobbes, known always as George to avoid confusion with the other Johns in the household. Later, in Geneva, they were to meet Joseph Couttet,

who was to act as courier and guide and *in loco parentis*. Couttet, in addition to contributing his knowledge of foreign manners and places, relieving Ruskin of many of the mundane burdens of travel, was also to make sure, on behalf of the senior Ruskins, that John always took "a squeeze of lemon in his water." Much can be deduced from frequent passages in Ruskin's letters home, as when he wrote from Florence, "I am very cautious about ladders, and always try their steps thoroughly, and hold well with hands."[3] Shrewd old Turner had foreseen all this, and had said to Ruskin, "Why *will* you go to Switzerland—there'll be such a fidge about you, when you're gone."

The party came into Italy along the Riviera, through Massa and Carrara, arriving in Genoa on April 26. Ruskin stayed here only three days, finding himself disappointed with such pictures as the city had on display, considering them mostly fakes and copies. The notebooks, however, as distinct from the letters, express admiration for Veronese's "Judith" and for some Mantegnas. Their first extended stay was at Lucca, where Ruskin worked for twelve weeks. Though he was primarily supposed to be looking at pictures, and Lucca boasted some good Fra Bartolommeos, from the letters to his father we can trace Ruskin's growing fondness for the Lombard style in architecture. In particular he admired the churches of San Frediano, San Michele, and the Cathedral, but above all he was captivated by one item within the Cathedral—the sculpted tomb of Ilaria di Caretto, by Jacopo della Quercia.[4] On May 14 Ruskin wrote to his father from Lucca, "I have discovered enough in an hour's ramble after mass to keep me at work for a twelvemonth. Such a church! So old, 680 probably, Lombard, all glorious dark arches and columns, covered with holy frescoes and gemmed gold pictures on blue grounds."[5] Two days later, in a long letter, he described a typical day's activities, reading up on local history, copying from frescoes and mosaics. E. T. Cook dates from this time in Lucca the clinching of Ruskin's vocation as architectural critic: "Thus began at Lucca Ruskin's first serious study of architecture," and adds that the buildings of Pisa, visited next, reinforced the experience.[6]

A less happy aspect of Ruskin's concern for architecture is also apparent in the early letters from Pisa—his thunderous and outraged denunciations against neglect on the one hand and the restorer on the other; the latter, in Ruskin's view, equally responsible for the destruction of ancient buildings. On May 13 he wrote: "While for want of glass and a good roof these monuments are rotting every day, the wretches have put scaffolding up round the Baptistery, and are putting modern work of the coarsest kind instead of the fine old decayed marble."[7] This note grows shriller and more insistent as Ruskin grows older, sounds through all his later architectural work at Venice, and eventually helps to inspire

William Morris' ''anti-scrape,'' the Society for the Protection of Ancient Buildings. There is a certain cultural irony in the transition from the earlier Ruskin, much imbued with the picturesque taste, seeking out ruins to make a scene delightful and evocative, even creating them where they were not—as in his drawing of the facade of San Michele at Lucca as a ruin[8]—and the later Ruskin angered and saddened by real neglect of the buildings he loved.

If Lucca can claim the major credit for turning Ruskin's eyes to Italian medieval architecture, setting him on a course that was soon to produce *The Seven Lamps of Architecture* and *The Stones of Venice*, then Pisa can claim, during this same tour, to have initiated a change in Ruskin's taste equally profound and influential. It was there that he began in earnest to shift away from the acknowledged masters of the High Renaissance, to the earlier, ''primitive'' painters of the late Middle Ages and early Renaissance.[9]

Ruskin was one of the first art critics to wander from the accepted Victorian orthodox belief, essentially the same as the eighteenth-century orthodoxy of Sir Joshua Reynolds, in the unrivalled supremacy of Raphael and Michelangelo, those masters considered most lofty and majestic in conception and most ''finished'' in execution. Beginning in the second decade of the century a few voices raised questions about this established order. Books such as Alexis Rio's *Poetry of Christian Art* (1844), and William Young Ottley's *Italian Schools of Design* (1823), and in America the writing and collecting of James Jackson Jarves,[10] paved the way for Ruskin to argue the artistic significance of early, then largely unknown artists, such as Piero della Francesca and Fra Angelico. Even Botticelli, to the Victorians, was thought an unconventional, ''aesthetic'' taste—one of *Punch*'s hallmarks of the too-precious aesthete. One of the problems for Ruskin was that this taste for the ''primitives'' often went openly hand-in-hand with pro-Catholicism; his shifting tastes in painting therefore involved him also in re-evaluation of his religious positions, and the relationships between religion, art and society.

While in Pisa during the spring of 1845 Ruskin saw for the first time the frescoes by Benozzo Gozzoli in the Campo Santo, and was impressed. The art historian and collector, Giovanni Rossini, whom Ruskin met in Pisa at this time, may have influenced his tastes in this direction, but the evidence is scanty. It was these same frescoes, as engraved by Lasinio, that later became one of the major inspirations behind the formation of the Pre-Raphaelite Brotherhood, whose relationship in the history of taste to the foregoing is obvious, and whose first vociferous public advocate, in a pamphleteering battle with Charles Dickens, was, of course, John Ruskin.

Perhaps because of the new-found interests in art and architecture, Ruskin's visit to Florence, where he now spent six weeks, was in marked contrast to the boredom and disappointment of his earlier stay. The galleries of that city he still found to be largely hot-beds of Renaissance corruption and degradation, but its churches were another matter. He spent days studying and copying in the Ghirlandaio Chapel of Santa Maria Novella, in the Brancacci Chapel decorated by Masaccio, and in Fra Angelico's St. Mark's Convent. Giotto now began to interest him for the first time. There was, as yet, no outright rejection of the High Renaissance, as codified by the Royal Academy, but the first rumblings are there, with the appearance of such remarks as, "Raphael and Michelangelo were great fellows, but from all I can see they have been the ruin of art."[11] Some copying was done in the Pitti Palace, a collection Ruskin preferred to the Uffizi, for which Lord Holland, then minister to Tuscany, had obtained permission. Holland also invited the industrious art historian to dinner to meet some of the Anglo-Florentine community, but Ruskin, then as always, showed little interest in society.

The party moved on to spend a few days in Parma, Piacenza, and Pavia on their way to Macugnana, where Ruskin's continuing fondness for Turner is proven by his insistence that they all should visit the nearby sites depicted by him.[12] Favorite Turner views were also objects of pilgrimage on the way to their next stop, Baveno, on the western shore of Lake Maggiore. They then made their way through Como, Bergamo, Desenzano, and Verona to Venice, where they settled for five weeks. At Baveno in the Italian Alps another member had been added to the party—J. D. Harding, a former watercolor teacher of Ruskin's. The two of them turned the remainder of the journey to Venice into a sketching tour. Other artistic society then in Venice included Mrs. Anna Jameson, at work on her *Sacred and Legendary Art*, a book not at all Ruskinian in approach. Also present was William Boxall, a Royal Academician and later Director of the National Gallery, who often accompanied Ruskin and Harding on their walks and sketching expeditions. In addition to his work in drawing, measuring and recording, Ruskin was writing comments on Italian art and architecture for *Murray's Handbook for Travellers in Northern Italy*. They were to be included in the third edition of 1847, and consist mainly of notes on churches in Carrara, Lucca, Pisa, and Florence.

Ruskin's artistic intentions during this stay in Venice had originally concerned chiefly Titian and Bellini, but the next major revelation of this tour, another clear turning-point in Ruskin's career, occurred when he and Harding decided to visit the then little-touristed Scuola San Rocco, with its vast Tintorettos. "I was never so utterly crushed to the earth before any human intellect as I was today—before Tintoret."[13] Elsewhere he says that, but for this visit, he might have written *The Stones of Chamouni*

instead of *The Stones of Venice*. As with the "discovery" of the early Italian masters in Tuscany, it cannot be claimed that Ruskin was alone or necessarily the first. Earlier artists as diverse as Sir Thomas Lawrence, William Etty, and Turner himself, had all admired the genius of Tintoretto when they had seen his work in Venice.[14] But this did not diminish for Ruskin the novelty of his experience, nor the impact with which, through Tintoretto, the full splendor of the Venetian Renaissance broke upon him. He always made a thorough distinction between this Renaissance, and the qualities both moral and technical to be found in its products, and the High Renaissance of Florence and Rome. The physical, tangible exuberance of form and color were new to Ruskin, and were things for which he had not in any way been prepared by his earlier tastes in painting. He wrote of Tintoretto often, but he best captured in a short space those qualities which swept him away in 1845 when he later reviewed Sir Charles Eastlake's *History of Oil Painting*.[15] He wrote:

> We find Tintoret passing like a firefly from light to darkness in one oscillation, ranging from the fullest prism of solar colour to the coldest greys of twilight, and from the silver tingeing of a morning cloud to the lava fire of a volcano: one moment shutting himself into obscure chambers of imagery, the next plunged into the revolutionless day of heaven and piercing space, deeper than the mind can follow or the eye fathom; we find him by turns appalling, pensive, splendid, profound, profuse; and throughout sacrificing every minor quality to the power of his prevalent mood.

His mind stocked with these new and consuming enthusiasms, Ruskin was back at Denmark Hill by the beginning of November and worked uninterruptedly on the second volume of *Modern Painters*, which appeared in April 1846. If the "object" of the first volume had been the vindication of Turner, then the second had two main purposes: firstly, to venture into the field of abstract aesthetics, never the one in which Ruskin was most at home, with an extended exposition of his distinction between Typical Beauty and Vital Beauty; and secondly, a task for which he was much better suited, to act as messenger and interpreter for two schools of Italian painting—that of Fra Angelico at Florence, and that of Tintoretto in Venice. E. T. Cook states categorically, if a little too simply, of volume two of *Modern Painters*, "It turned the taste of the age to the primitives."[16] He points to the fact that the National Gallery now started to buy early Italian paintings; he mentions, too, the foundation of the Arundel Society.[17] which commissioned those influential engravings after the frescoes of Benozzo Gozzoli at Pisa. It would soon be possible, looking to other levels of cultural expression, for *Punch* to create Mrs. Cimabue Brown.

Though the stay in Venice might be most memorable for the discovery

of Tintoretto, Ruskin's concern for architecture, which had taken such leaps forward at Lucca and Pisa, also figures largely in his correspondence. In particular, in the letters to his father his complaints about "restoration" and "modernization" have grown both in frequency and intensity. He laments the "fearful dilapidation" of the palaces on the Grand Canal,[18] and bemoans the city's installation of gas lamps "of the latest Birmingham fashion." He tells his father that he must stay in Venice longer than he had expected "to get a few of the more precious details before they are lost forever." St. Mark's was being scraped and cleaned, so "off go all the glorious old weather stains."[19] Patent iron railings were appearing on bridges, modernism was everywhere, as if "your very gondola has become a steamer." He calls the Ca' d'Oro "the noblest Palace on the Grand Canal,"[20] but is saddened by the state into which it has been allowed to fall. Venice has become a symbol of the fallen Eden, a moral for us all to observe. The city's decay merely hardened Ruskin's resolve, true pedagogue, to record and publicize all that he could. During this stay he produced many marvellous drawings of the Ca' d'Oro and other buildings. He discovered, too, as an aid to topographical drawing, the wonders of the daguerreotype—"every chip of stone & stain is there—and of course, there is no mistake about the proportions."[21] It comes as a slight surprise to find Ruskin so unquestioningly embracing a modern mechanical innovation.

Accompanying all this, and connected with it, is an omnipresent feature of Ruskin's letters and diaries from Italy, one not so far dealt with—an unrelenting and sometimes ferocious anti-Italianism. The letters to his father during 1845 are full of it, and it might seem odd to some Ruskin readers to encounter such sentiments from a man who, after all, devoted most of his working life to the study of Italian culture, and who spent long stretches of his time travelling and living in Italy. One should remember that, in the midst of his rapture over the art and architecture of Lucca, he described the people he encountered there as

> knaves of the first and most rapacious water. Never content, get what they will—always sulky—fifty people at a time holding out their hands to the carriage. Custom houses every five miles—one for passports, another for searching luggage, and all asking barefacedly and determinedly for money. I would give ten times the sum, willingly, to see something like self-respect and dignity in the people, but it is one system of purloining and beggary from beginning to end, and they have not even the appearance of gratitude to make one's giving brotherly—they visibly and evidently look upon you as an automaton on wheels out of which they are to squeeze as much as they can, without a single kindly feeling in return.[22]

And all of this, an ironic sidelight on notions of the "golden age" of travel, from a man protected by a courier and a servant from the worst incon-

veniences attendant upon the journey. On another occasion he admitted, "I am not pleased with the Tuscan and Lucchese population. The beggars are as great a nuisance as the mosquitoes."[23] From Florence he wrote that the people are "listless, chattering, smoking vagabonds," and after several pages in the same vein concludes, "Take them all in all, I detest these Italians beyond measure." When in the Alps again, at Macugnana, where, though the town is politically Italian, language and culture are German, Ruskin rejoiced at being "out of Italian smells and vileneses."[24] He generously conceded that the Venetians "are far superior to the rest of the Italians," though on the scale he has established this is not saying much, "as far as one can judge by external appearances and expression of feature—they are more amiable and more busy." Lest this rather less than generous praise be thought too much, he goes on to qualify it by pointing out their fundamental baseness and stupidity.[25]

All of this strikes an unpleasantly discordant note when juxtaposed with his admiration for pictures and buildings. It posed Ruskin the problem, of course, of how a country peopled by such contemptible creatures can nonetheless produce a Tintoretto and a Ca' d'Oro. It is a question closely related to the other, and even more troublesome, one—how can a despicable and superstitious faith produce great religious art. He never came up with an answer to either question. It is tempting to picture an over-protected and somewhat priggish Englishman of twenty-six, puritanically raised, possessed of a mother capable of sending him Bunyan's *Grace Abounding to the Chief of Sinners* as fit reading for travelling in Italy. Certainly a deeply inbred anti-Catholicism struggled hard within Ruskin with an admiration he could not suppress for works of art created by Catholic artists in a Catholic society. How to admire Italian churches while despising the Italian Church, that was his problem, and the virulence of his attacks on the Italian people reflects that tension. It is also possible that a more devious Ruskin is, in part at least, working hard to keep his parents happy. Devout Scottish Evangelicals as they were, the threat of their son going over to Rome was a constant fret to them. Recent years had seen the Oxford Movement, Newman and Manning; Cardinal Wiseman was soon to be very much in the public eye, and in 1850 Pius IX was to reinstate the Catholic hierarchy in England.[26] In the 1840s, as later in the 1890s, there seemed to be a curious but undeniable link between the aesthete and the convert. Italian life and culture did in fact induce a major upheaval in Ruskin's religious faith, one that might well have resulted in another man in conversion to Rome, but which in his case led rather to a kind of aesthetic humanism. At this time, though, his Walworth Protestantism is still largely unshaken, and he may in those letters be assuring his parents of the fact. At another

level, though one hesitates to attribute to Ruskin such a degree of cynicism, his strictures on the baseness of the Italian character, because of the corollary that they neglect and abuse their buildings, provided him with an excellent excuse for prolonging his stay repeatedly, which he did, "to get a few of the precious details before they are lost forever."

Venice Preserved

It speaks well for Ruskin's humanity and filial devotion, but less well for his critical judgement, that in 1846 he insisted, as soon as the second volume of *Modern Painters* was in the press, that he be allowed to take his mother and father to Italy in order to share with them the discoveries and enthusiasms of the previous year. At the age of twenty-seven he felt the impossibility of a thing so vital to himself being closed to his parents. He wished for them, particularly, to see Lucca and Pisa, and of course Venice. It was to prove to be the last time the elder Ruskins would see Italy. It was also to be the last trip the three of them were to take together before John's marriage, and it brought about, prior to that marriage and in some ways preparatory to it, if not exactly a gulf between them, at least a recognition on both sides of how far the developing tastes of the son had removed him from the world of his parents. Ruskin was now forced to recognise that he and his father, formerly so close, had grown apart in their artistic tastes and in their capacities to absorb fresh artistic experience. The diary was once again faithfully kept, perhaps because Ruskin no longer had the automatic, enforced diary of daily letters home. From it we can learn much of their itinerary, the points of greatest interest on it, and of the growth of Ruskin's professional attitude towards what he saw.

The departure date, as it had been on the previous year, was April 2. They were away until October. Most of April was spent travelling at a leisurely pace through France, where the architecture now absorbed Ruskin's attention far more than it had before. In particular, he had a new-found interest in the Cathedral at Chambéry.[1] They arrived at Como and were visiting the Cathedral there by May 7, the diary at this point containing a drawing of a door molding from that building. Such architectural sketches have now replaced the earlier, usually botanical or geological diary illustrations. Three days later they arrived in Verona, where the church of San Zeno came in for much praise, and at which point the diary contains the first extensive and explicit treatment of Italian

Gothic. If the formative journey of 1845 divides fairly equally between painting and architecture in its "discoveries," there can be no doubt that this time architecture predominates. The diaries, once filled with little sketches of rocks and cloud formations, now abound with detailed drawings of doorways, moldings, and lintels. It seems that the appearance of several books, including some of those already mentioned, on medieval art and architecture was a factor in refiring and focusing Ruskin's enthusiasm for the Gothic of Lucca and Pisa, and in encouraging him, during this visit, to make a closer and more scientific study of it. He now looked at the favored sites of earlier journeys with a more critical and professional eye. Between this tour and the next to Italy *The Seven Lamps of Architecture* made its appearance, and it was at this time that Ruskin was collecting most of the material for it. Tracing his development in this way, one sees that what was new and revelatory in Ruskin's architectural writings was precisely that he was the first to study buildings— classifying them, putting their traceries under a microscope—as previously men had studied only rocks and plants.

Venice was reached by May 14, and again the diary is filled with writings and sketchings of the architecture of the city as never before, and in particular is much concerned with the capitals on the Doge's Palace, later to figure so prominently in *The Stones of Venice*. A letter from John Ruskin senior to his friend Mr. Harrison, written from Venice at the end of May, gives one view of the widening gulf between father and son mentioned earlier.[2] John James had always been paternally proud of his son's picturesque drawings and watercolors in the Proutian, Turnerian tradition, but he found difficulty in adjusting to his new techniques and approaches:

> He is cultivating art at present, searching for real knowledge, but to you and me this is at present a sealed book. It will neither take the shape of picture nor poetry. It is gathered in scraps hardly wrought, for he is drawing perpetually, but no drawing such as in former days you or I might compliment in the usual way by saying it deserved a frame; but fragments of everything from a cupola to a cartwheel, but in such bits that it is to the common eye a mass of Hieroglyphics—all true—truth itself, but Truth in mosaic.

For the other side of the coin, here is Ruskin's own rationalization of the causes of this growing problem. On the subject of northern Gothic, with which his father would have been more familiar, their tastes still remained close enough; but Ruskin's new enthusiasm for the Gothic of Tuscany and Lombardy was a sticking point:

> There began now to assert itself a difference between us I had not calculated on. For the first time I verily perceived that my father was older than I, and not immediately

nor easily to be put out of his way of thinking on anything. We had been entirely of one mind about the carved porches of Abbeville, and living pictures of Vandyck, but when my father now found himself required to admire also flat walls, striped like the striped calico of an American flag, and oval-eyed saints like the figures on a Chinese teacup, he grew restive . . . my father and I did not get on well in Italy at all, and one of the worst, wasp-barbed, most tingling pangs of my memory is yet of a sunny afternoon at Pisa, when just as we were driving by my pet La Spina Chapel, my father, waking out of a reverie, asked me suddenly, "John, what shall I give the coachman?" Whereupon I, instead of telling him what he asked, as I ought to have done with much complacency on being referred to on the matter, took it upon me to reprove, and lament over, my father's hardness of heart, in thinking at that moment of sublunary affairs. And the spectral spines of the Chapel have stayed in my own heart ever since.[3]

This regrettable deteriorization in understanding between father and son was the price that had to be paid for Ruskin's vastly matured and enriched architectural tastes. Between this Italian journey and his next, as a married man in 1849, he had established a considerable name for himself as the "Graduate of Oxford," writing with an unprecedented authority on matters of art, and, most importantly, he had begun to establish himself as a prominent critic of architecture. In 1847 the *Quarterly Review* had asked him to review Lord Lindsay's *Sketches of the History of Christian Art*.[4] In June of 1849 *The Seven Lamps of Architecture* had appeared, the fruit of the researches into French and Italian Gothic during the tours of 1845 and 1846.

It was the need to apply the abstract principles of the *Seven Lamps* to a particular physical and historical setting that took Ruskin to his next major undertaking, *The Stones of Venice*, and to his next stays in Italy, longer by far than any he had taken before.

It is clear that by the time of the publication of *Seven Lamps* Ruskin already planned *Stones;* an advertising page in the back of the first edition announces the latter work as forthcoming. He married Effie Gray in April 1848, and it seems likely that they intended to take their honeymoon in Italy, as John was anxious to get to work on his new project. There had been, however, major uprisings in both Venice and Milan. One month earlier Daniele Manin had declared the restoration of the Venetian Republic, initiating a lengthy siege and bombardment by the Austrian forces. So they took their honeymoon instead in Normandy and Brittany.[5] By the time they considered it safe to visit Venice in the following year it was only the second time they had travelled abroad together, the hostilities were by no means ended, and they were virtually the only English in the city, a fact which caused certain social difficulties, for Effie more than for John.

The bizarre saga of the Ruskin marriage is to be found in almost

everything ever written on the man. The married lives of famous people, especially if bumpy and ultimately broken, exert a powerful fascination. It would be out of place in the present study to do it full justice, for which the reader is referred to a full-scale biography; some mention of it must be made, however, insofar as it affects the Venetian stays.

Essentially, the marriage ended after five years when Effie walked out, claiming that it had never been consummated and that she had been subjected to unendurable psychological torture. The claim of non-consummation was never legally challenged by Ruskin, and Effie was granted an annulment. The bitterest controversy in the history of Ruskin scholarship grew up around the question of guilt and responsibility for the breakdown of the marriage. The battle lines are represented by Sir William James' *The Order of Release* on the one hand, and J. Howard Whitehouse's *Vindication of Ruskin* on the other. James was a relative of Effie's and set out to portray his kinswoman as a wronged innocent; Whitehouse set out to do exactly what his title suggests. Neither side was entirely free of bitterness and acrimony, which was sometimes inherited by later followers and apologists on both sides. The chief issues were these: the manner of Effie's leaving, stealing off in the dead of night without a word to anyone. Was this underhanded and hugger-mugger, or was it understandable in a woman so abused? What to make of the moot issue of Ruskin's impotence, and of his touching offer to prove the contrary in court? What was the role of the elder Ruskins—concerned parents or interfering busybodies? Certainly they made little pretence of their dislike for their daughter-in-law, that fact being made all the worse by the circumstance of the Ruskins and the Grays being blood relatives.

These questions are examined in lurid detail elsewhere, most notably in Mary Lutyens' series of books. Her approach and conclusions are distinctly pro-Effie. Other biographers, particularly Joan Evans and John Dixon Hunt, tend to see things more from Ruskin's point of view. There is also a chapter in the fascinating *Parallel Lives* by Phyllis Rose dealing with the disasters of the Ruskin marriage. It is an issue in the present narrative because one of the sadder themes running through these Venetian stays is the obvious breakdown of their relationship.

But this is to anticipate. One supposes that no such dreary thoughts bothered the minds of the recently married couple when they set off for Venice, though Effie, after over a year of unconsummated marriage, might have been developing some forebodings.

These two visits to Venice, in 1849/50 and 1851/52, are better described as stays than tours, since on both occasions very little travelling was done except within the city itself. The next stage in Ruskin's development as a writer required him to place his architectural studies firmly within a

specific social and historical context, demanding close and exhaustive study of a single city, Venice, not only for its art and architecture, but also for its historical, social and economic basis. It was Ruskin's sense of the necessity of this connection, first expressed in the famous "Nature of Gothic" chapter, that directed his energies within a few years to *Unto This Last*.

It is important to see this continuity in order to appreciate the full significance of Venice in Ruskin's entire career. The city is present in his life and his writings from his earliest Byronic effusions to the last, half-sane visions of Carpaccio's *St. Ursula*. Ruskin once described himself as a "foster-child of Venice," claiming that the city had "taught me all that I have rightly learned of the arts which are my joy."[6] *The Stones of Venice* has a strong claim to being considered Ruskin's greatest work. It is certainly his most logical and organized. He once called the whole of *Modern Painters* an expanded explanation of a parenthesis in *Stones*.[7] And it can be argued that his dramatic shift to socio-economic writing in the 1860s was in large part a response to the questions concerning the relationship between art and society raised by *Stones*. As subsequent chapters will show, it was to Venice, after an absence of seventeen years, from 1852 to 1869, that Ruskin returned for his most productive later work, *St. Mark's Rest* and his Carpaccio studies. In short, Venice was a powerful force throughout Ruskin's entire career, not just a part of it. It was both a storehouse of treasures for him, with its buildings and pictures, and also a symbol of glorious achievement followed by decline and decay, a moral fable revealed, for Ruskin, by a proper reading of its art, and intended as a warning to nineteenth-century England.

If the letters and the diaries of the earlier journeys provide a good picture of Ruskin "on the road," then the sources for these two longer Venetian stays vividly depict his domestic and daily routine while abroad. Equally clear during these months is the breakdown of the Ruskin marriage. It may well be that the unusual strains placed upon their relationship by John's single-minded devotion to his work, exacerbated by the strangeness of a foreign city, new to Effie, did not help matters. But their marriage, only eighteen months old, was already in trouble by the time they arrived in Venice in November 1849. It is well known that Effie and her parents-in-law did not get on. It is less well known that earlier, in the Spring of 1849, Ruskin had travelled through Switzerland with his parents, partly to recuperate from his completed labors on *The Seven Lamps of Architecture*; Effie had been packed off to Scotland to stay with her family.

Having arrived in Venice, then, in November, John and Effie straightaway established themselves at the Hotel Danieli. With them was

Charlotte Ker, a friend of the Gray family, indicating that even from the outset it was realized that John would not provide much social companionship for Effie.

They had reached Venice by way of Geneva, crossing the Simplon to the Lakes, where they visited the palace of Count Borromeo on Isola Bella, before moving on to Milan. Already by this stage of the journey it is clear from Effie's letters home that her interests were exclusively social, and the higher the level of society involved the better.[8] While Ruskin busied himself visiting buildings and picture galleries, Effie's letters tell how, in the very next room to their own, resided Princess Samoilow, a close friend to Radetzky, commander of the Austrian forces. From Verona she wrote on November 8 an ominous prelude of things to come in Venice:

> John has written to England to Lady Davy and others for some letters of introduction for us that Charlotte and I may go into a little society at Venice and Florence, and as he is so busy he would like us to get acquainted with some English and amuse ourselves, and during the Carnival we may have some amusement without troubling him.

As was mentioned earlier, there were, in view of the recent political and military turbulence, very few English people then in Venice.

By November 13 Effie's letters were sent from Venice, letters largely concerned with her health, always troublesome, her wardrobe, and her coiffeur. She describes a trip across the Lagoon to the Lido, so, for the first day or two at least, she did not feel neglected by her husband. Already by November 15, however, she is lamenting that "John is very busy in the Doge's Palace all day," leaving her and Charlotte to go off on a shopping expedition together.[9] On November 19 she writes, "Today John was occupied all the forenoon working at the Casa d'Oro,"[10] though later that day he did take her to the Scuola San Rocco to see the Tintorettos, a tourist visit for her but work, of course, for Ruskin—twenty-six pages of the "Venetian Index" describe its pictures. On November 27, "we went to St. Mark's where we found John near the high Altar stretched all his length on the ground drawing one of a series of exquisite Alabaster columns surrounded by an admiring audience of idlers."[11]

Eventually, Effie did receive a few letters of introduction to prominent Venetians, such as the Marquis Carlo Torrigiani, but not enough, apparently, to prevent a note of bitterness creeping into the letters. For December 10 we have, "John has just gone out in the rain to call on Mr. Blumenthal who left his card for us on Saturday as we were out which I hope will bring us some acquaintances. John could and would make plenty if he had time."[12]

So much for Effie's occupations and aspirations during their first stay in Venice together. Something of her husband's activities has already been seen from her point of view. He was working more intensely than ever before. The "sense of mission" that had sprouted within him nearly a decade ago had been growing ever since and was now in full flower. These present labors were to produce the first volume of *The Stones of Venice* in March 1851, with the second and third volumes following in the wake of the second stay.

Various critics and biographers have noticed that *The Stones of Venice* involved in its writing a scope of intellectual endeavor and a methodology quite new to Ruskin. It was by far the most ambitious project he had ever tackled, arguably the most ambitious he was ever to tackle during his entire career. For the work on the book Ruskin devised a more elaborate system of research methods than he had previously used, employing two notebooks, one supposedly for purely artistic matters, the other for historical and archival research. Typically of Ruskin, they soon became confused and their purposes mixed. They are, of course, filled with sketches and measurements, of the sort that his father had quite failed to see the point of in 1846. Ruskin, however, in a way that might seem somewhat surprising to the modern mind, was thoroughly without training in the kinds of historical and archival research necessary to his plans. He had been at Oxford, but to receive a gentleman's education, and a gentleman's education in the 1830s was an unprofessional thing. *The Stones of Venice*, requiring a comparative method, a close grasp of chronology, and a sense of documentary sources, involved Ruskin in areas of scholarship wholly new to him. It is at this point that his friendship with Rawdon Lubbock Brown became so valuable to him, and so relevant to the tracing of the Italian biography. Some knowledge of this unusual and interesting man, generally treated slightly or not at all in lives of Ruskin, is essential to a proper understanding of the Venetian work.

Rawdon Brown was, amongst other things, an accomplished historian, and is chiefly known for his work in the Venetian archives. So shaky has been his reputation, living only in the footnotes of other people's biographies, that even the *Dictionary of National Biography* has his birthdate wrong—giving it as 1803 instead of 1806. He was thus Ruskin's senior by thirteen years. Supposedly, he had fallen in love with Venice in 1833 while on a visit there, and had not been able to bring himself to leave. The *Dictionary of National Biography* says, again incorrectly, that he never left the city of his adoption from that day until his death fifty years later. He was, in fact, in London at least once during that period, for he attended the Great Exhibition. But the point is a small one. It is certainly true to say that, for the greater part of his adult life,

he hardly ever left his beloved Venice and became, in the words of Joan Evans, "the leading Englishman in Venice,"[13]—though she, too, is guilty of propagating misinformation, calling him an Oxonian, for which there is no evidence. The only documented education he is known to have had was at the Charterhouse, 1820/21.

Initially interested in the Venetian tomb of Sir Thomas Mowbray, Shakespeare's "banished Norfolk," Brown's great historical discovery was of the documentary value of the diplomatic "news-letter" sent by the Venetian ambassador to the Court of St. James back to his republic. In 1854 he published "Four Years at the Court of Henry VIII" from the dispatches of Sebastian Giustiniani. Brown always harbored the hope that one day he might himself be offered a Consulship. He never was. The only official post he ever secured came to him in 1862, when Palmerston, impressed by his archival work, gave him a pensioned commission to edit all the Venetian state papers with any bearing upon English history. This he did, in eight volumes, a task which occupied the rest of his life, the final volume appearing posthumously.

Rawdon Brown's usefulness to Ruskin was twofold: intellectual and practical. Intellectually, as a chronicler and historian trained in archival scholarship, he had much to teach Ruskin on methodology. And on a purely practical basis one cannot overestimate the importance of the introductions he gave to Ruskin—to libraries and galleries, private scholars, owners of houses or paintings he wanted to see. Brown's position in Venetian society made him the ideal intermediary between Ruskin and La Serenissima. Ruskin, in terms of the work he was involved in, suffered from three impediments: he spoke little or no Italian; he disliked Italians; he was socially graceless. Rawdon Brown made up for all three deficiencies.

The best way to see the various ways in which Rawdon Brown helped Ruskin, and to understand the nature of their friendship, which lasted over thirty years, is to read the correspondence between them. Since this has never been published as a collection, and only small bits of it have appeared here and there, an appendix has been included in the present work which summarizes its major points and quotes from it where useful. Given the long period it covers, from 1850 to 1881, and the centrality of the topics discussed to Ruskin's work, it forms a fascinating biography-in-miniature.

During the autumn of 1849 Ruskin was being guided by Rawdon Brown through the intricacies of Venetian scholarship, as preparation for his task in hand. Of particular usefulness was the introduction to Giambattista Lorenzi, sub-librarian at St. Mark's Library, where Ruskin did most of his research into the chronology of the Ducal Palace, upon which

so much of the argument of *The Stones of Venice* depends. In a letter to his father, December 23, 1849, he says, "Mr. Brown recommended me one man as the only one who knew *anything* of those connected with the library of the Ducal Palace."[14] Later, in a letter from the second of the two Venetian stays, Ruskin says of Rawdon Brown, "his knowledge of the antiquities of Venice was profound." Without Brown's good offices Ruskin's researches into the historical background for *Stones* would have been much less thorough, or else would inevitably have taken him longer. Lorenzi, incidentally, as readers of the Rawdon Brown Appendix will see, was handsomely repaid for any assistance he gave to Ruskin.

Perhaps the most remarkable thing about Rawdon Brown, in relation to the Ruskins, is the fact that he immediately became, and despite the divorce remained, a good friend to them both. Indeed, in their early Venice days it is Effie's letters home that say more of him than John's. She was highly enthusiastic about him in a letter of December 22, 1849, calling him "a most agreeable, clever literary person and yet not all that grave."[15] Poor Effie! What a view of intellectuals she had derived from her husband. Two days later she wrote that Rawdon Brown "took us into six or seven churches," and that "Mr. Brown has also promised to present us to the young and old mesdames Mocenigo."[16]—a telling combination of services. Brown even, and this seems to have been the way to Effie's heart, took an active interest in her perpetually problematic health. Presumably in response to some complaint or other, he advised her to rub herself, morning and night, with hair gloves, to "promote circulation." She had her mother send her a pair.

On January 6, 1850, she describes going to Rawdon Brown's house, perhaps for the first time, saying it was "furnished in such exquisite taste," with many old and valuable manuscripts, and so forth.[17] She describes the quality of his conversation, and refers to his habit, surely the mark of the true historian, of discussing historical figures as if they were still alive. On March 9 she tells of a lunch given by Brown: "I never saw anything more perfect, the glass, china we ate off, the little cups of black coffee, served in the most exquisite style, and then the little liqueur glasses of Rossolio and a most splendid bouquet in the centre for me which I think had stripped away every Camelia from the Botanical Gardens."[18] Brown gave her a brooch on this occasion, a head of Bacchus: "was it not very kind of him?"

It was no small achievement to remain on friendly terms with both John and Effie, especially after the annulment. The reason is clear. Each of them separated and enjoyed only one side of Rawdon Brown's more rounded character, while he combined within himself something of the interests of them both. To Ruskin he was antiquarian, scholar, and aesthete,

sharing his immense knowledge of Venetian history, giving hints, tips, and introductions to libraries; to Effie he was a charming host, less "grave" than her husband, a witty and gossipy snob and socialite, invaluable for her entrees to the Mocenigos and others of the Venetian *monde*.

When the Ruskins returned to Venice, this time with John Hobbes, known as George, on September 1, 1851, it was for a second stint of work, lasting until June of the following year, that was to see the completion of *The Stones of Venice*. They moved into the Palazzo Businello, Rawdon Brown's guests. Ruskin's letters to his parents during this stay have been edited and provide a full picture of his daily activities. Effie's continue to tell much the same story as before: she was bored, increasingly exasperated by her husband's neglect, ever more desperate for society to amuse her. Often their two paths are shown quite graphically separate: "Effie is gone out with Lady Sorel to the Countess Esterhazy's—and I stay at home to read Venetian history."[19]

After spending eight days in Brown's apartments, they settled into lodgings, apparently found for them by their host, in a house in the Campo Sta. Maria Zobenigo, belonging at the time to the Baroness Wetzler and so sometimes referred to as Casa Wetzler. It is now the Gritti Palace Hotel. The Ruskins thought this arrangement would be both more convenient and more economical than a second protracted stay at the Danieli.

It must not be supposed that Ruskin could altogether avoid social obligations. E. T. Cook says of this period that they "received occasionally in a quiet way,"[20] and there was always the necessity of being hospitable to passing Englishmen, such as Sir Gilbert Scott and that redoubtable traveller Lord Dufferin. Cook goes on to add, however, "nothing was allowed to interfere for long or seriously with the steady prosecution of his work." It might tell us something of Ruskin's industry, and perhaps also something of his character and state of mind, to recall that besides working to complete *The Stones of Venice* during this stay, he also composed a ninety-page commentary on the Book of Job.[21]

Effie's letters for 1851/52 faithfully present the same picture, but from her viewpoint, being filled with such remarks as, "John has gone as usual to Murano and draws there till dinner time."[22] Effie was now much in the company of the Countess Palavicini, and was a familiar face in both the Austrian and Russian social circles of the city. It is easy to imagine that Ruskin would have been relieved to have Effie thus taken off his hands; he may even have been proud of her ease and success in society. But if so he showed no inclination to become involved in it himself. Richard Ellmann, in a highly suggestive essay,[23] offers a psychologically darker interpretation of events, arguing the deep emotional impact of his

wife's (supposed) adultery upon Ruskin, in connection with his developing obsession with virginity, and innocent, unspoiled femininity. This makes the metaphorical and dramatic movement of the *Stones*, the city's degradation from chaste medieval maiden to Renaissance whore, an autobiographical symbol. If this seems far-fetched, it is nonetheless undeniable that Ruskin worked hard throughout the entire project of *The Stones of Venice* to "personalize" things as far as possible, partly by emphasizing, perhaps over-emphasizing, what he saw as close parallels between England and Venice: that both were "free" societies but traditionally conservative and aristocratic; that both were Christian but considerably independent of Papal authority; that both had developed large mercantile empires based upon sea power. That resounding, admonitory first paragraph, and the reasons for Ruskin's wrapping himself in Cassandra's mantle, become clear only in the light of this parallel. One should notice, too, the peculiar and willful juggling with dates throughout *Stones*, dating, for example, the actual fall of the city with ludicrous specificity and for no very convincing reason, to May 8, 1418, exactly four hundred years before his own conception—his mother's fall from innocence.

Their friendship with Rawdon Brown, despite his hospitality to them, or perhaps because of it, suffered strains during this visit that had not been apparent before. Effie wrote home, "I see Mr. Cheney and Mr. Brown very seldom. . . . Mr. Brown never asks me to come and see him although I call regularly on both as politeness requires but there is something about them both that I can't make out at all."[24] In similar vein, Ruskin wrote on April 21, 1852, of Brown, "He is as *kind* as ever, but we see little of him, for he is as jealous as he is irritable—he has quarrelled with everybody who lives in Venice and does not come to see us lest he should meet them in our drawing room."[25]

Ruskin may have hit upon part of the reason for their strained relations, but there are other possibilities. For one, the above-mentioned Edward Cheney, a close friend of Rawdon Brown and like him an antiquarian, connoisseur, and collector, whom Ruskin once described as "a kind of Beckford,"[26] had, for whatever reason, an immense and bitter dislike of Ruskin. Cheney once wrote to his friend, Lord Holland, from whom Ruskin had earlier received diplomatic aid in gaining access to private collections:

> Mrs. Ruskin is a pretty woman and is a good deal neglected by her husband, not for other women but for what he calls literature. I am willing to suppose that he has more talent than I give him credit for—indeed he could not well have less—but I cannot see that he has either talent or knowledge and I am surprised that he should have succeeded in forming the sort of reputation that he has acquired. He has so little taste that I am surprised he admired Holland House.[27]

It is not difficult to see a fundamental incompatibility between Ruskin and Edward Cheney, one which must to some extent include Rawdon Brown too. Cheney and Brown were both essentially eighteenth-century dilettanti, highly social and cultivated men for whom scholarship, in controlled amounts, was an urbane achievement. The evangelical intensity of Ruskin's vocation was a thing altogether different, and very much of the nineteenth century. This, coupled with personal oddities, and Ruskin's, for them, utter social gracelessness, would have erected insuperable barriers between them. Ruskin, beyond a certain point, would simply not have been their sort. And he saw that, quite clearly. He wrote to his father on October 11, 1851, describing Brown and Cheney as "of a different species from me—men of the world—caring very little about anything but Men."[28]

More specifically, Ruskin and Cheney crossed swords when Ruskin wrote to the Trustees of the newly established National Gallery in an attempt to persuade them to buy for the nation two Tintorettos, one of them the famous "Marriage in Cana." Sir Charles Eastlake, head of the Gallery and President of the Royal Academy, and with his wife, the art critic Elizabeth Rigby, very much in the anti-Ruskin camp in terms of the politics of the Victorian art world,[29] wrote to Cheney for his opinions of these paintings. Receiving a far lower estimate of their artistic merit and financial worth, Ruskin's offer to act as intermediary for the purchase was declined. Ruskin never forgot or forgave this, and says in *Praeterita*[30] that Cheney "put a spoke in the wheel for pure spite." Whatever Cheney's motives, it may be said, with comfortable hindsight, that he was very wrong, and Ruskin right.

At the beginning of May 1852, the Ruskins' lease with the Baroness Wetzler expired and they moved into apartments in Piazza San Marco. Ruskin had been detained, partly by this business over the Tintorettos, and partly by the curious episode of the theft of some of Effie's jewels. It was late in June before they left the city. When they returned to London it was to a new house in Herne Hill that Ruskin's father had found for them. During that autumn, winter, and the following spring Ruskin was giving the final shape to his Venetian material, and the second volume of *The Stones of Venice* appeared in July 1853, containing the famous "Nature of Gothic" section. The third and final volume came out in October, by which time they had taken the fateful summer holiday in Glenfinlas where Effie met John Everett Millais, her future husband. By the time Ruskin is next in Italy, in 1858, the marriage will have been annulled for four years, and Effie, with a consummated marriage at last, will boast of a son.

Calvin versus Veronese

After leaving Venice in June 1852 with all the research needed for the completion of *The Stones of Venice*, it was to be six years before Ruskin was again in Italy. In the meantime he had become a single man once more, and had seen through the press volumes three and four of *Modern Painters*. He had made two foreign tours, both to Switzerland and on both occasions in the company of his parents. There was always a side of Ruskin which considered, almost begrudgingly, that all his mighty labors on Italian medieval art and architecture constituted a kind of enforced interlude from his real work, a task he had merely to get out of the way before he could return to *Modern Painters*. This six-year absence from Italy is explained by his feeling that his work there, for now at least, was done, and there were other tasks needing attention. For Ruskin, there were always other tasks waiting in the wings. No doubt also, after the debacle of the marriage breakdown, Venice in particular would have harbored unhappy memories and associations. It is a well known, and surely a telling, oddity that *Praeterita* makes not a single mention of Effie.

Other important developments, changes of interest and direction, had been taking place. He was by now much involved with the Working Men's College, and in his lectures his growing political concerns were becoming ever more apparent. he was clearly on the path that would soon lead to *Unto This Last*, in some ways his most influential and certainly his most controversial book. The Italian journey of 1858 was crucial in determining and strengthening the temperamental shift resulting in this major turn in the direction of Ruskin's energies and the nature of his writings.

He travelled this time without his parents, leaving England in May. He passed in a leisurely manner through Switzerland, and by the beginning of June was crossing the St. Gothard to Bellinzona.[1] June and early July he spent on the Lakes, at Locarno, Baveno, and Isola Bella. A diary entry shows him in Baveno on July 11, reading Dante's *Purgatorio*.[2] Then, from July 15 until August 31, he spent almost seven weeks in Turin, then the capital of the Kingdom of Sardinia. Interestingly, he arrived there by

train, an experience he very much enjoyed.[3] Thus he did not penetrate very far on this occasion into Italian territory. He felt no need to revisit such favorite places as Lucca and Pisa; Venice was still perhaps too painful.

The most significant event of this tour, in terms of Ruskin's development as a writer, was the so-called "unconversion" which occurred in the Waldensian Chapel at Turin. The story is a familiar one, and can be read in complete detail in any of the full-scale Ruskin biographies. Essentially, Ruskin saw the event, in retrospect in *Praeterita*, as the loss of his childhood faith. In Turin's Protestant Waldensian Chapel Ruskin attended a service where "a little squeaking idiot was preaching to an audience of seventeen old women and three louts that they were the only children of God in Turin; and that all the people in Turin outside the Chapel, and all the people in the world out of sight of Monte Viso, would be damned." Disgusted and depressed by this, Ruskin walked to the gallery where Veronese's "Queen of Sheba" was to be seen.

> The windows being open, there came in with the warm air, floating swells and falls of military music, from the courtyard before the palace, which seemed to me more devotional, in their perfect art, tune, and discipline, than anything I remembered of evangelical hymns. And as the perfect colour and sound gradually asserted their power on me, they seemed finally to fasten me in the old article of Jewish faith, that things done delightfully & rightly were always done by the help and in the spirit of God.[4]

His Walworth Protestantism would never be the same again.

One can simplify the highly involved psychology of this episode by saying that the important outcome was Ruskin's realisation of the, for him, inextricable fusion of moral and artistic concerns. Of course, the Old Testament being his literary and ethical mother's milk, he had always tended to see things moralistically. The particular brand of Evangelical Protestantism upon which Ruskin was raised made much of the kind of allegory and typology that enables the whole of human experience to be "read" as a sort of moral parable.[5] Ruskin had already "read" the monuments and artifacts of Venice in much this way, interpreting her art, her life, her rise to and fall from power, as just such an admonitory anecdote. But all this tended to be rather mechanical—the imposition of an external construct for a preconceived end. What happened to Ruskin during the summer of 1858, during his stay in Turin, was the internalization of this connection, the turning of the outward system inside to the soul of man. It is tempting to trace parallels with some of the other famous *crises de foi* to which Victorian men of letters seem to have been so prone; one thinks especially of Carlyle and of J. S. Mill.

In one of the *Fors Clavigera* letters[6] Ruskin discusses his frequent oscillations of taste from one style of painting to another. It is possible to detect a basic pattern, a see-saw rhythm alternating between an ideal of disembodied purity on the one hand, and of worldly lavishness and sophistication on the other. It is the movement from Titian to Fra Angelico, from Tintoretto to Carpaccio. The discovery of Veronese in the Gallery at Turin in the summer of 1858 is one of the most dramatic manifestations of these swings of taste, which do, however, run through Ruskin's entire career.[7] Veronese burst upon him much as Tintoretto had done in Venice in 1845. it is with words like "majesty" and "power" that Ruskin describes his sense of glorying in the sheer physical exuberance, the "gorgeousness of life" that he finds in Veronese. But this time certain connections are made that were not made in the Scuola San Rocco, and Ruskin saw that not just art was involved in his response, but all of religion and morality. It is only after this episode that Ruskin could be capable of his famous dictum that "taste is morality." Within Veronese's brain, he says, "all the pomp and majesty of humanity floats in a marshalled glory, capacious and serene like clouds at sunset." Is he a servant of God, he asks, or of the Deveil? And then, "it is all very well for people to fast, who can't eat; and to preach, who cannot talk or sing; and to walk barefoot, who cannot ride, and then think themselves good. Let them learn to master the world before they abuse it."[8]

There is a danger of oversimplifying the complexities of spiritual biography, taking advantage of novelistic coincidence and neatness. The danger is especially great in the case of an author whose own autobiography is so artfully crafted. Clearly, thoughts and insights of the kind here described go back at least as far as the discovery of Tintoretto. Perhaps the "crisis" of 1840 could be convincingly presented as a similar struggle between sternly moral mental horizons and an irrepressibly passionate and sensuous nature.[9] But now these rival impulses precipitate a spiritual upheaval of greater magnitude, during which the personality seems to disintegrate and be reassembled in altered form. Perhaps the growing mental problems of Ruskin's middle and old age are evidence that the reintegration was only partially achieved.

Ruskin's "unconversion" was merely the most emphatic of several spiritual oscillations that punctuate his life. But the evangelical faith of his childhood had gone never to return. At certain later points in his life, as for instance under the influence of Carpaccio's *St. Ursula*, he once more approached a type of Christian belief; but it is of a soft and sentimental sort, very different from the "Walworth" brand under which he had been raised. By and large, after these experiences in Turin, Ruskin's Christian faith is replaced by what he was later to call the "religion of humanity."

This he explained as the belief that "human work must be done honour-ably and thoroughly, because we are now Men;—whether we ever expect to be angels, or ever were slugs, being practically no matter." Also, "in resolving to do our work well is the only sound foundation of any religion whatsoever."[10] The link to Carlyle and to F. D. Maurice's Working Men's Institute is clear to see, as is the emergence of the socio-economic writings of the 1860s.

It should perhaps be pointed out at this stage that several serious-minded biographers, rendered suspicious by the novelistic neatness of the chain of events, have baulked at the story as here presented. There are problems with it. The chief source for the "literary" version is *Praeterita* itself,[11] but another version occurs in *Fors Clavigera*[12] in which the sequence of events is reversed—that is to say the visit to the Waldensian Chapel now follows a lengthy and devoted study of Veronese. Augustus Hare, in his autobiography, has left us a view of Ruskin at work making copies from this same canvas, but he is imprecise as to dates. The diary entry for the time[13] says a great deal about Veronese's "Queen of Sheba," but only in connection with a despised Canaletto exhibited with it and more popular; nothing is said of it in the light of sermons or any other non-artistic activity. We know now, since the publication of Ruskin's letters to his father for the 1858 tour,[14] that the letters, like the diaries, do not express any momentous sense of occasion at the time. The letters im-mediately following that Sunday, August 1, are quite bland. It was not until Wednesday, August 4, that any mention was made of his having visited the Waldensian Chapel, when he complained only of the "vulgar" and "disagreeable" piety there presented.[15]

There may be more than one possible explanation for the discrepancy. It may have been that Ruskin did not wish to alarm his parents, who already anguished quite sufficiently over their son's spiritual welfare. Equally likely is the fact that Ruskin may have seen this Sunday in August as such a watershed in his life only in retrospect, when he came, in *Fors Clavigera* and in *Praeterita*, to present his life to the public.

The understanding of the present-day reader might be helped by viewing the whole episode in a broader biographical framework than either of Ruskin's own versions provide. John Dixon Hunt points out in *The Wider Sea* (p. 262) that it was at about this time that Ruskin discovered the existence of Turner's erotic drawings. The knowledge that his childhood artist-hero, the supreme colorist, the unparalleled landscapist, had also produced these all-too-worldly outpourings, must have been an enormous shock to the naively inexperienced and sexually confused Ruskin. In addition, there are various letters from this period (*Collected Works*, 36, 275-76, 279-80) giving voice to his growing dislike of the strict

evangelicalism of Bunyan, Calvin, Knox and others. The wisest interpretation is probably that the Waldensian preacher acted as a catalyst in a process long fermenting, precipitating and clarifying ideas and emotions that Ruskin had been worrying for some time. In retrospect, in highly artistic and self-conscious retrospect, he made that one incident serve as the symbol for all.

What then were the consequences of this eventful afternoon, however understood, in the Waldensian Chapel and in the Veronese Gallery, on Ruskin's writing? His "religion of humanity," by fusing, or confusing, art and the moral life, leads directly to *Unto This Last* and all of the copious socio-aesthetic essays of the 1860s and 1870s. In fact, Ruskin had prepared some political papers on "The Italian Question" during this tour, which he expected to publish in an Edinburgh journal, *The Witness;* but his father interceded with the editor to prevent their appearance. Such side glimpses put into clearer perspective the strains there were between father and son. The fifth and final volume of *Modern Painters,* out in 1860, is filled with this new humanism. Most profoundly, from this point on, Ruskin's entire approach to the judging of paintings is different. He had already, in the "Nature of Gothic" and elsewhere, shown us how to assess architecture not in terms of abstract principles or of its effect on the observer, but according to whether or not the workmen who put it up were happy in so doing. He now began to take the same approach with pictures, which are to be judged according to the happiness they express on the part of the artist. Ruskin comes quite surprisingly close to Bernard Berenson's "life-enhancing" principle. He wrote to Charles Eliot Norton, "I've found out . . . that, positively, to be a first-rate painter you *mustn't* be pious; but rather a little wicked, and entirely a man of the world. I had been inclining to this opinion for some years; but I clinched it at Turin."[16] The reader may care to recall, and contrast, how Ruskin had used the phrase "man of the world" earlier, to describe Rawdon Brown and Edward Cheney. The semantic shift is a milestone in Ruskin's spiritual growth.

It is hard to overestimate the significance of the major realignment in Ruskin's system of values brought about by the confluence of events described above. One's appraisal of Ruskin's status and development as writer and critic must stand or fall by it. Depending on one's viewpoint, as of July 1858, Ruskin, enriched by the recognition of moral and artistic complexities never before fully realized, becomes a vastly more complex, if also more diffuse, critic of life and art; or else John Ruskin, confused and befuddled by a welter of aesthetic and philosophico-religious conundrums he never had any hope of resolving, is catastrophically diverted from the one area of his true expertise into a wasteland of increasing inconsequence, his writings losing the focus they earlier possessed,

becoming episodic jottings of bewildering eclecticism. All lives, all studies
of Ruskin, must choose and follow one of these two paths.

The decade from 1858 to 1869 is the least eventful of Ruskin's life for
southern travels. He visited Italy only once during those years, in 1862,
and that visit was a brief one, involving only Milan.

The occasion for this journey was Ruskin's new passion, thoroughly
in keeping with the changes in taste precipitated by his experiences in
Turin four years earlier, for Bernardino Luini, an artist he praised for his
richness of color and atmosphere. He left England on May 15 with two
new travelling companions, Edward and Georgiana Burne-Jones. Edward
Burne-Jones, Oxford friend and associate of William Morris, and one of
the enthusiastic group responsible for painting the Pre-Raphaelite murals
in the Union there, was at this time beginning to assume the role of
Ruskin's favorite acolyte. He was to maintain that position for a number
of years, gradually displacing D. G. Rossetti, an earlier occupier who had
proved recalcitrant and disappointing in the role.[17]

They made for Switzerland, then crossed the St. Gothard to Milan,
where Ruskin settled for two months of study, chiefly on the Luini
frescoes in the Monastero Maggiore at San Maurizio.[18] Luini was another
artist Ruskin took the credit for having "discovered," that is to say, for
having brought to wider public notice. Once again his work was partly
on behalf of the Arundel Society, and it involved only one short excur-
sion, to Saronno, a cathedral town some thirteen miles northwest of Milan
on the road to Como, where more Luinis were to be found. In this same
year Ruskin was awarded an honorary membership of the Florentine
Academy, in recognition of his services to the cause of Italian art, but
he showed no inclination to travel farther south.

After a few days in Milan he sent the Burne-Joneses off to Verona,
Padua and Venice as his guests, but did not accompany them. This in
no way suggests weariness with their company; he was always eager to
have followers and proteges about him, and he seems to have found
Burne-Jones most pliable and gentle after the moody Rossetti. But he was
very much absorbed in his own work, which, in addition to Luini, in-
cluded working on the first essay of *Munera Pulveris*, requested by *Fraser's
Magazine*. Ruskin seems to have been somewhat lethargic and suffering
from stress during this time in Milan. He wrote to Charles Eliot Norton
that his work in the city "utterly prostrated" him,[19] and as soon as it was
finished he retreated to the quieter atmosphere of Mornex in Switzerland
for the rest of the summer.

From 1862 to 1869 was an unusually long interval for Ruskin to be
absent from Italy, especially since the visit of 1862 was so short and

involved so little travel. Various reasons have been put forward by critics and biographers to explain this gap, usually along the lines of demonstrating his consuming interest in the social welfare of his own country and a corresponding diminishing of concern for the life and art of the south. That the length of this absence was in no way conscious or planned, however, has become clear since the publication of the correspondence of Ruskin to Pauline, Lady Trevelyan.[20] And the point is reinforced by the Rawdon Brown correspondence.

Pauline Trevelyan, née Jermyn in 1816, was a close friend of Ruskin's for many years. She and her husband, Walter Calverley Trevelyan, both loved to travel, and she, in addition to being an occasional art critic and reviewer, with several favorable notices of Ruskin's publications to her credit, was an early champion of the Pre-Raphaelites. In fact the Trevelyan house in Northumberland, Wallington Hall, became a showplace of Pre-Raphaelite principles in practice. The walls and columns of the central hallway were decorated with naturalistic scenes by several artists, including Ruskin himself.[21] She and Ruskin first met in 1847, probably introduced by Sir Henry Acland. They met frequently thereafter, the Trevelyans being often invited to Denmark Hill when in London, and Ruskin staying frequently at Wallington. The early correspondence shows that until the divorce Pauline was also a good friend to Effie.

Ruskin spent much of his time during the early 1860s in Switzerland, in a kind of self-imposed exile during which he harbored serious thoughts of settling there permanently. It is clear that he intended to revisit Venice from Switzerland during the autumn of 1863. In a letter to Pauline Trevelyan, October 1, 1863,[22] he said:

> On the whole it seems to me best to go and have another look at Venice, while some of it is still standing, and I've a dear old friend there—Mr. Rawdon Brown who will be so glad to see me—and so will my old boatman, and I want to see the Paradise of Tintoret once more—in case I never see anybody else's Paradise—so send me a line to Venice, please.

He later added as an afterthought that she should, after all, send word to Geneva, as he was not quite sure of his Venice plans. He wrote to Rawdon Brown[23] to inquire about the chances of buying an apartment in Venice, "somewhere on the Grand Canal or by the Ponte dei Sospiri quarter." This was shortly before he actually did buy his Swiss property. The reader might also refer to the letters in the Rawdon Brown Appendix for June 11, 1866, and September 20, 1868.

In a similar fashion he wrote again to Lady Trevelyan in mid-March 1866, saying that he felt he needed a change: "I just want to race to Venice and back in about six weeks, to look at a Titian or two." They all planned

to travel together through Switzerland and into northern Italy. But by this time Pauline had become ill, though determined to continue travelling. Ruskin wrote, "I do truly hope that Baveno and Lugano . . . will be more health giving than the ashes of Auvergne,"[24] and says in the same letter, "one of my chief objects in going at all being to see the Crucifixion at Lugano," referring to a painting by Luini. However, all plans for Italy were abandoned when Lady Trevelyan died on her travels, on May 13, 1866, at Neuchâtel.

Slade Professor

As a result of the combination of accidents and uncertainties outlined in the previous chapter, it was not until 1869 that Ruskin was again in Italy. His recent interests had been steadily turning him away from the isolated study of art towards a more socially focused view of things. The publications of the 1860s show us Ruskin as critic of society. Beginning with the controversial *Unto This Last*, which appeared serially in the *Cornhill Magazine* in 1860, Ruskin went on to offer *Fraser's Magazine* further essays on social and political economy during 1862/63, the *Cornhill* being reluctant to accept more after having had to withdraw the earlier series in response to public outcry. The second series became *Munera Pulveris*. His continuing concern for the art of life rather than the life of art shows again in *Sesame and Lilies* (1865), and in the lectures collected as *The Crown of Wild Olive*, (1866). More letters to newspapers on the subject of the Ideal State later appeared as *Time and Tide* (1867). Then in 1869 came *The Queen of the Air*, ostensibly a group of lectures on Greek myths, but, to say the least, discursing on a wide variety of other topics, chiefly of a political nature.

In addition to these productions, all on broadly social themes, Ruskin continued his lifelong devotion to the study of geology, and in 1865 he published *Ethics of the Dust*, written in the format of a collection of letters to the girls of Winnington School. It is a definite indication of Ruskin's changing sense of his audience and the best way for him to approach his public that the productions of the 1860s, instead of appearing as multivolume scholarly works, all take the form of journalism, letters and lectures. The liaison with Winnington School marks the start of Ruskin's curious fixation on young girls, to become such a feature of his later life, and which was, especially in the case of Rose La Touche, to cause him so much sadness. It was, in fact, in the midst of these political writings that he proposed to Rose La Touche.

Ruskin had met Rose in 1858, when she was nine years old, and had given her drawing lessons. In 1866, when she was seventeen and he forty-

seven, he proposed marriage. She was never able to give a definite answer one way or the other, but her parents were strict Evangelicals suspicious of Ruskin's wavering faith, as well as of his divorced condition. To make matters worse, Rose herself was a very sickly young woman, physically and mentally, with a nasty form of religious mania with which she goaded Ruskin. She died insane in May of 1875, but that, unfortunately, did not mark the end of Ruskin's obsession with her, as will be seen in the next chapter.

After Rose there was Francesca Alexander, then Kathleen Olander and Susan Beever—only the principal names in a succession of young girls who were to occupy much of Ruskin's attention and emotional energies for the next two decades. They were usually art students, and were often involved in one of Ruskin's "causes" or benevolent social activities. His father had died in 1864, leaving him a great deal of money, most of which went to financing these various "causes," ranging from his neo-Arthurian St. George's Guild to Mr. Ruskin's Tea Shop.

So there was no real need, while these other concerns absorbed him, for any contact with his beloved Italy, after his major books on her art and architecture had been published, and before his Slade Professorship. Because he had no reason to, he did not go to Italy for seven years. It need hardly be said that Ruskin did not travel to Italy, as modern travellers generally do, to "get away from" anything, to rest or relax. He went there for specific purposes, having work to do that required being in Italy. Of course, this is not to say that the impact of Italy on his life did not extend beyond professional requirements. But it is surely the case that with the appearance of *The Stones of Venice* almost all of Ruskin's original work on Venetian material, and on Italian subjects generally, was already over. The later Italian writings are largely reworkings and adaptations.

With Switzerland the situation was different. There, too, his original impetus had been evangelically laborious, the Alps being the perfect hunting ground for Ruskin the geologist. But by the 1860s Switzerland does seem to assume the nature of a retreat of sorts, a place he turns to for rest and recuperation. He had spent from June 1861, to the end of 1863 largely in exile at Mornex, in part out of despondency at the reception of *Unto This Last*.[1] He gave serious thought to settling there permanently. It is a sad turning-point in Ruskin's life when he begins, as he does at this time, to travel for escape rather than for inspiration.

Italy, however, still meant work. Its buildings and paintings were his vocation, or had been until the lure of socialism had entered his life. He began to return there on a frequent and regular basis when his career required it—when his growing role as teacher and art educator made it necessary for him to take young artists there; when his Slade Professor-

ship obliged him to set about the business of preparing lectures, very many of which were to deal with Italian subjects.

The topic of Ruskin as teacher and educator is a large one, beyond the scope of the present work. It is enough to say here that, with the years, his earlier and fresher sense of "mission" hardens into the didacticism, sometimes playful, sometimes ferocious, of the Victorian schoolmaster. All of his subsequent trips to Italy are, in some way or another, a feature of this pedagogical impulse, a measure of his need to instruct. His remaining books on Italy take the form of guidebooks and student manuals; they add no original research to what he had already done, years before, nor do they add any fresh insights. It is the manner and the presentation which have changed; they re-present familiar material with the student or the traveller specifically in mind.

It was while he was in Italy, in Verona, where he arrived on May 8, 1869, that Ruskin received the offer of the Slade Professorship of Art at Oxford; and it was at Lugano on August 14 that he heard of his election. He had embarked on that journey, already assuming his role as mentor, with a clutch of proteges, notably J. W. Bunney, whom Ruskin had met through the Working Men's College, and who was to become famous, in some circles, notorious, for a painstaking rendering in oils of the facade of St. Mark's. Also of the party was Arthur Burgess, a wood engraver who was to help with the restoration work on the Scaliger Tombs at Verona, undertaken once again on behalf of the Arundel Society.[2]

One of Ruskin's reasons for returning to Venice after an absence of seventeen years was to reconsider the conclusions he had reached in *The Stones of Venice*. He wrote to his mother on August 7, "that after seventeen years I can certify the truth of every word in *The Stones of Venice* as far as regards art."[3] Those last five words express volumes, and remind us, in particular, that the visit to Turin of 1858 had intervened. He still complained bitterly about various "restoration" projects, especially that involving his favorite Castelbarco Tomb in the church of St. Anastasia. In June he met Henry Wadsworth Longfellow, probably on the introduction of Charles Eliot Norton, and in July he spent some time in the city with W. Holman Hunt, another of the original Pre-Raphaelites, but one with whom Ruskin had been on somewhat strained relations because Hunt had remained a close friend of Millais. A note of gloomy depression at the thought of the sufferings of others begins to pervade the letters home. He wrote to his mother on June 17, after describing some particularly lovely scenes of natural beauty, "All these things do not make me happy—nothing will ever do that: and I should be ashamed if anything could, while the earth is so full of misery."[4] However, he had also written, soon after his arrival in Venice, "I am much surprised to find how great pleasure I can take in this place still."[5]

The artistic "discovery" of the visit of 1869 was Carpaccio.[6] He wrote to Burne-Jones on May 13, "This Carpaccio is a new world to me."[7] This rather overstates the case. The taste for Carpaccio is best seen as the latest swing of the pendulum back towards the "pure" and "ideal" extreme, after the lengthy glorification of Veronese and other "fleshly" masters. And as before the art historians are quick to point out the thinness of Ruskin's claim to any "discovery" of that artist. In fact, according to Joan Evans,[8] Burne-Jones himself had directed Ruskin's attention to Carpaccio, though the tone of Ruskin's letter certainly suggests he had forgotten that, or else chose to ignore it. It is known that there was already a "Pre-Raphaelite" taste for the artist, as for many other painters of the Quattrocento. Three years earlier the National Gallery had spent £3,000 on a picture ascribed to Carpaccio. What is undeniable, however, is that Ruskin did much to popularize Carpaccio by his writings on him.

Another of the fruits of this trip, restricted as it was to northern Italy, was the lecture on "Verona and Its Rivers," delivered in February 1870, to the Royal Institution. Also in Verona he produced an elaborate drawing of that city's Piazza dei Signori.[9]

The first lectures by the new Slade Professor began in February 1870. The series was later collected as *Lectures on Art*. From that time on Ruskin's visits to Italy were at least partially motivated by professional necessity. He earnestly started to assume the role of the Professor, internally and externally. More and more of his lectures and publications were composed for a specific audience and with a specific educational objective in mind. The powerful pedagogical strain within him, dating from that famous first sermon at the age of four, now came into its full glory; people came to know him and think of him as "The Professor"—the title of the memoir of Ruskin written by Arthur Severn, son of Keats' friend Joseph, and for many years in Ruskin's service.

On April 27, 1870, Ruskin left for Italy with an unusually large retinue, consisting of Joan Agnew, his housekeeper and later the wife of Arthur Severn; Mrs. Hilliard, who was the sister of Pauline Trevelyan, and her daughter Constance, a friend of Joan Agnew's and young enough to be a favorite of Ruskin's. Also of the party was a maid for all the ladies, Ruskin's valet, Crawley, and also Downs, his gardener, who was to be consulted over certain of Ruskin's Alpine schemes. This greatly increased retinue in part reflects Ruskin's wealth since the death of his father; and in part, too, it shows him growing into the role of guide and mentor.

The party travelled through France and Switzerland, arriving in Milan on May 20. They were in Venice five days later, where Ruskin was soon engrossed in his old labors, sketching palazzi and studying Carpaccio,

for whom his enthusiasm was unabated. His mental equilibrium, however, more and more tenuous as he grew older, was not helped by all the changes in his favorite city, observed now over a period of more than thirty years. The letters are frequently nostalgic and depressive in tone, like this to Norton: "Day by day passes, and finds me more helpless; coming back here makes me unspeakably sad."[10]

Also, and quite ironically considering that his own writings were in no small part to blame, Ruskin complained for the first time of the unbearable pressure of tourism:

> I can't write this morning, because of the accursed whistling of the dirty steam-engine of the omnibus for the Lido, waiting at the Quay of the Ducal Palace for the dirty population of Venice, which is now neither fish nor flesh, neither noble nor fisherman— cannot afford to be rowed, nor has strength nor sense enough to row itself; but smokes and spits up and down the piazzetta all day, and gets itself dragged by a screaming kettle to Lido next morning, to seabathe itself into capacity for more tobacco.[11]

Besides Carpaccio, Ruskin was again enthusiastic over Tintoretto and he initially planned to devote all five of the autumn Slade lectures to one painting of his, the "Paradise." In Pisa and Florence, however, where the party was in late June and early July, he "discovered" Filippo Lippi, about whom he also wished to talk, so Tintoretto was relegated to a single lecture in the revised scheme. As things turned out his second set of lectures concerned chiefly Greek and Florentine coins and sculpture. Only one lecture was actually on Florentine painting, and that was omitted as odd-man-out when the others were collected as *Aratra Pentelici*. A talk given in June 1871 on "Michelangelo and Tintoretto" was another product of his researches and reflections during this tour. It caused some scandal in the art world by its one-sided praise of the latter at Michelangelo's expense, and prompted a response from Sir Edward Poynter, who then occupied the corresponding Slade Professorship at London.

After Florence and Pisa, the party moved on to Siena, where they stayed with Ruskin's old friend Charles Eliot Norton. They left Italy on July 7, and were back in England by the end of the month, their departure having been hastened by the outbreak of the Franco-Prussian War.

On April 13, 1872, Eastertime, Ruskin set out again for Italy, partly to recover from the death of his mother in December of the previous year, and partly to see "where also he might gather material for future lectures."[12] He took with him Joan and Arthur Severn, the two people who were to keep house for him and generally look after him for the rest of his life, the two Hilliards, mother and daughter, Crawley the valet, and another artist protege, Albert Goodwin. They travelled by way of Geneva

to Genoa, and arrived at Ruskin's favorite haunts of Lucca and Pisa by April 27, staying in those two towns until March 8. Predictably, both the beloved Chapel of the Thorn at Pisa, and the adored Chapel of the Rose at Lucca were being "restored"—"Two of my favourite buildings in Italy have been destroyed within the last two years, and I am working day and night (or at least early morning) to save a few things I shall never see again."[13]

The party then headed south through Florence, where they spent three days, arriving in Rome on May 12. At Rome Botticelli[14] became the "discovery," one of which Ruskin seems to have needed on each visit to Italy. His prejudice against Michelangelo was confirmed by a visit to the Sistine, the roof of which he called "one of the sorrowfullest pieces of affectation and abused power that have ever misled the world."[15] Notice, in view of what has been said about Ruskin's growing pedagogical drives, the use of the word "misled." From Rome they wended their way through the hill towns of Assisi, Perugia, Siena, and Orvieto to Verona, where Ruskin wrote a monograph on the Cavalli monuments for the Arundel Society. There is, incidentally, no mention of Giotto during the two days spent at Assisi. They reached Venice by June 23 and stayed for three weeks, during which time Ruskin returned to his Carpaccio studies. By way of Milan, Como and the Simplon they were back in England by the end of August, and by September 13 Ruskin was established in his newly acquired house in the Lake District, Brantwood.

In his new home the Slade Professor immediately set about preparing his next series of lectures, for the Michaelmas term, November and December 1872. He was, naturally enough, full of his experiences in Italy that summer, and in particular elated at the thought that he was the first to bring the attention of the English public to Botticelli, though in fact Walter Pater had published an article on that painter in the *Fortnightly Review* in August 1870. Ruskin had originally intended to call these lectures "Sandro Botticelli and the Florentine Schools of Engraving," planning, as he wrote to Norton,[16] to "correct Vasari." These papers were later collected and published as *Ariadne Florentina*. The *Val d'Arno* lectures, also prepared on this journey, were delivered in the Michaelmas term of 1873.

It is not often that we are offered an oblique view of Ruskin on his Italian travels, provided by a journal or letters other than his own. For the tour of 1872 we have such a view. Arthur Severn wrote a quite extensive narrative of the party's travels, which later formed a large section of his book *The Professor*, a memoir of his life with Ruskin.[17] Though his is a tale of "a most delightful time in Italy," he early warns us that "it must not be imagined that these continental tours which Ruskin made

were sight-seeing holidays. Far from it; they were very much working tours."[18] He goes on to give detailed descriptions of Ruskin rising at four in the morning, long before the rest of the party, and reminds us that his master, besides all the work on hand in any given location, always travelled with the proofs of works currently going through the press, or else was writing prefaces for new editions of earlier works, and so forth. In this category were the *Instructions* for the Oxford Drawing School which Severn tells us Ruskin produced during this trip.

Severn gives us some interesting insights into the social dynamics of the Ruskin group. All but Ruskin himself seem to have found Genoa not at all to their liking. "He came in at last . . . told us what beautiful things he had seen etc. etc. We in our turn told him how bored we all were." Ruskin's remonstrances and persuasions were of no avail on this occasion and they soon left. As always, memoirs like these tell as much about their author as about their subject.

We are shown Ruskin at work. Severn describes him at Pisa, marvelling at his head for heights, drawing a carving on a column, "with crowds looking over his shoulder. He never minded people watching him in this way. I fancy he considered it rather a compliment to his skill."[19] It would not be hard to find letters of Ruskin's rebutting this interpretation.

The visit to Rome on this journey was, according to Severn, largely for his sake, his father still being alive and now acting as British Consul there. He tells us that Ruskin was reluctant to go to Rome, and that his spirits picked up immensely when the party moved on to Assisi and Perugia. When they all arrived in Venice Severn says that "old Mr. Rawdon Brown came to meet us with his gondola."[20]

The three latest journeys to Italy have shown, if not exactly a different Ruskin, a Ruskin whose motives for travelling and whose image of himself as a traveller are considerably altered from earlier days. His once highly personal sense of mission has become professional and didactic. He travelled with specific educational objectives and often in the company of young artists he wished to train to see with his own eyes.

He embarked at the end of March 1874, upon a seven-month journey with Italy as its focus which, according to E. T. Cook, "affected vitally Ruskin's views upon Italian art."[21] It provided the material out of which grew the lecture series "The Aesthetic and Mathematic Schools of Art in Florence" and *Mornings in Florence*. The "discovery" this time was Giotto.

He took no friends with him on this occasion, nor any artist apprentices, just his valet Crawley and a courier named Klein. He had begun in a state of deep depression, which he attributed to the strain of his lecture schedule. He was seriously considering giving up his Professorship. By the time he reached Pisa, however, on April 9, he was able to tell Joan

Severn that he was feeling better. As a measure of his returning high spirits, he came surprisingly close, for him, to saying something flattering of the Italians: "the essential sweetness of character of the people generally, polluted and degraded as they are, touch me more deeply every time I return to Italy."[22]

From Pisa Ruskin progressed to Assisi for the chief object of the current tour. He was to superintend, as a council member of the Arundel Society, the copying of some of Giotto's frescoes in the church of San Francesco.[23] The reader will recall a similar project involving the frescoes of the Scrovegni Chapel at Padua. He first stopped briefly in Assisi on his way south, to make a general inspection before returning later for a protracted stay. He moved on to Rome, never a favorite city, and then to Naples, if anything even more despised. He dubbed Naples "certainly the most disgusting place in Europe," combining "the vice of Paris with the misery of Dublin and the vulgarity of New York." Ruskin had, by the way, never visited New York, and had been to Dublin once, briefly.

These strictures upon the Renaissance and Baroque capitals of central Italy hardly come as any surprise. What is surprising is that now for the first time, after forty years of visiting Italy, Ruskin ventured south of Naples. He sailed from Naples to Palermo, leaving at 6:30 in the morning and arriving at 9:30 at night, April 22, 1874.[24] He had been pressed to come and pay a visit by his friends Colonel and Mrs. Yule and their daughter Amy, who were then living in Palermo. Ruskin was much impressed by the magnificence of Mt. Etna, over which he saw dawn appear on April 26, and he called the Sicilian coastline "unequalled in luxuriance of beauty."[25] He was also much taken with the curious novelty of Sicily's highly individual Moorish and Saracenic versions of Norman architecture, quite unlike anything he had seen before. He was correspondingly unimpressed by the Sicilians themselves—"this entirely neglected and lost people." He made a number of drawings, including views of Etna, from Taormina, and more of the tomb of Frederick II at Palermo. He then returned to Rome for what was to prove his last sight of that city, apparently without having troubled to visit, committed anticlassicist that he was, any of the justly famous Greek temple sites of Sicily, at Segesta, Agrigento, and Selinunte.

Most of the two weeks he now spent in Rome was devoted to making a painstaking copy of Botticelli's "Zipporah," and, in the intervals, looking over medieval churches. A letter to Joan Severn, written on June 4, is worth quoting in full for its revealing and colloquial picture of a typical Roman day for Ruskin:

> I've never told you—though I've meant to twenty times—how I spend my Roman day.
> I rise at six, dress quietly, looking out now and then to see the blue sky through the

pines beyond the Piazza del Popolo. Coffee at seven, and then I write and correct press till nine. Breakfast, and half-an-hour of Virgil, or lives of saints, or other pathetic or improving work. General review of colourbox and apparatus, start about ten for Sistine Chapel, nice little jingling drive in open one-horse carriage. Arrive at Chapel, sauntering a little about the fountains first. Public are turned out at eleven, and then I have absolute peace with two other artists—each on a separate platform—till two, when public are let in again. I strike work; pack up with dignity; get away about three; take the first little carriage at door again, drive to Capitol, saunter a little about Forum, or the like, or into the Lateran, or San Clemente, and so home to dinner at five. Dine very leisurely; read a little French novel at dessert; then out to Pincian—sit among the roses and hear band play. Saunter down Trinita steps as it gets dark; tea; and a little more French novel; a little review of day's work; plans for tomorrow; and to bed.[26]

After such days as this in Rome Ruskin made his way back to Assisi, where he now settled to several weeks of hard work. His eyes were opened as never before to the genius of Giotto, which genius, together with the spirit of St. Francis, permeates all his later writings. At this stage in his life Ruskin was highly susceptible to the appeal of the cloistered, religious life of contemplation and good works. His personal disappointments, especially the disastrous liaison with Rose La Touche, and the constant disillusionment over the reception of his writings, all tended to guide him in that direction. It was in Assisi at this time that Ruskin came as close as he ever came to converting to Roman Catholicism. He did not, of course, do so; but it is certain that his soon-to-be-founded Guild of St. George, with its quasi-medieval and monastic structure and principles, owes much to his exposure to the contemplative ideal of the Franciscans at Assisi.

Ruskin was given special permission to use the sacristan's cell at San Francesco for his work, and he relished its spartan monkishness in one of the letters of *Fors Clavigera*.[27] He became as friendly with and as fond of two of the monks, Fra Antonio and Fra Giovanni, as he ever did with any Italians—"They are both so good and innocent and sweet, one can't pity them enough"[28]—though why they are to be pitied for those qualities is not clear. Sir William Richmond gives us the story of coming upon Fra Giovanni at a later time and finding that he kept, wrapped up in a handkerchief, letters from Ruskin, which he treasured like the relics of a saint.[29]

Ruskin had expressed doubts as to the authenticity of all the Giottos in the Upper Church at San Francesco.[30] His work there, accordingly, was mainly in the Lower Church, where he was permitted to erect scaffolding the closer to examine those works that most interested him—the frescoes showing the marriage of St. Francis with Poverty, Chastity and Obedience, and a St. Francis in glory. There was also, in the south transept, a Cimabue Madonna and Child that enormously impressed him—"Yesterday discovered Cimabue in lower church altering my thoughts of all early Italian art."[31]

It has already been observed that, for Ruskin, a major shift in artistic tastes, such as that referred to above, did not happen in isolation. It usually heralds an equivalent upheaval in the moral sphere. These weeks in Assisi, studying Giotto in the church of San Francesco, inaugurate, or indicate, a shift in Ruskin's spiritual outlook almost as profound as that of the Waldensian Chapel in 1858, though in the opposite direction. Just as he had, on that earlier occasion, lost his evangelical faith in a spiritual turmoil that affected his views on art as much as his religion, so now he was able to say, after lengthy study of Giotto's frescoes, "I discovered the fallacy under which I have been tormented for sixteen years—the fallacy that Religious artists were weaker than Irreligious."[32] Sixteen years, of course, takes one back to 1858 and Turin. His "religion of humanity" has been supplanted by a more conventionally Christian ethos, and the sensual, life-affirming artists like Titian and Veronese are thrown into the shade once more, now seen as the inferiors of a Giotto, supported by his simple faith. Giotto was called "a very much stronger and greater man than Titian," and his work "quite above everything that Titian had ever done."[33] From now until the end of his writing career his tastes and opinions reflect these values, are more distinctly Christian in tone, though with a Christianity far softer and more humane than that with which he was raised. His diary entries covering the period at Assisi testify to a renewed burst of Bible reading.[34] The reading of the Bible was always for Ruskin, true to his evangelical upbringing, the real cornerstone of faith, rather than prayer or sacrament. He loved to dispute over Biblical texts with the monks, and quite failed to see, still confined within the lonely spiritual horizons of his childhood faith, that he was missing the point of their religious brotherhood. Ruskin never had any true sense of community in religion; perhaps that is why he strove so desperately to achieve it on a secular level. The sacristan whose cell Ruskin was using, no doubt sensing this growing need, prayed daily for his conversion—"C'è una piccola cosa, ma credo che San Francesco lo farà." This according to Oscar Browning, the aesthete and historian of Eton and King's College, Cambridge, who was in Assisi, following Ruskin's footsteps, in the winter of 1874.[35] Though he never joined the Roman church, Ruskin ever afterwards thought of himself as in some occult sense a "brother" of St. Francis. There is an odd moment in *Deucalion* where, amidst several pages of geological speculation, triggered by the memory of a passage from Dante, he calls himself "a brother of the third order of St. Francis."[36]

After this extended and highly formative sojourn in Assisi, Ruskin moved on to Lucca, where he promptly returned to the study of his beloved Ilaria di Caretto, and also of the Nicola Pisano sculpture over

the door of the Cathedral. He then spent a month in Florence, chiefly engaged in the work in the Spanish Chapel out of which grew *Mornings in Florence*. Visiting the galleries, his admiration for Botticelli increased; indeed, he says that working on his "Madonna Enthroned" and "Madonna Crowned" was an experience comparable only to finding Tintoretto in the Scuola San Rocco. He made many studies, too, from the "Primavera." To Joan Severn he once again confided the minutiae of his daily routine. And the diary entries for these days, in the midst of much gloom over his health, the weather, the ruin wrought by restorers, can still provide a rending remark like "Yesterday through the Uffizi, wishing I was a boy again, and feeling myself just able to begin to learn things rightly."[37]

Thus ended the journey to Italy of 1874. He did not revisit Venice. At Oxford in the autumn he delivered two series of lectures. The first was on "Mountain Form" and "The Alps and Jura," in November 1874, and it reappeared in *Deucalion* in the following year. The second series was entitled "The Aesthetic and Mathematic Schools of Art in Florence," containing much material on Giotto and Cimabue, Pisano and Ghiberti, Fra Angelico and Botticelli. These lectures were never published as a collection, but much of their content was taken for *Mornings in Florence,* published in installments, 1875/77. Cook calls this work "as familiar a companion to the tourist in Florence as Baedeker itself."[38] It is likely that also during this trip most of the preparation had been done for *The Laws of Fésole,* of course in drawing for his students at the Oxford Drawing School, which was not published until 1877/79. It was to have been followed by a companion course dealing with coloring, to be called *The Laws of Rivo Alto,* but this never appeared. It may be purely accidental that it did not, but it is tempting to see its abandonment as symbolic, for it was to have involved primarily the great Venetian masters of color, for whom Ruskin had largely lost his taste by 1874, having veered once more, after his experiences in the Italian hill towns, towards the Religious Ideal.

The Last Three Visits

As we have seen, Ruskin did not feel the need to revisit Venice in 1874. The painters and sculptors who were then occupying his attention took him to Tuscany. Two things prompted him to travel to Italy again, and to Venice specifically, in the autumn of 1876: the first was the recent death of Rose La Touche, throwing him into a deep depression, for which he always considered travel and work the best antidotes; the second involved a member of the Royal family. Prince Leopold, youngest son of Queen Victoria, and the only one of her children to manifest any concern for the fine arts, had gone up to Christ Church in 1872 and had attended Ruskin's Slade lectures.[1] Leopold was later to become one of the Trustees of the Ruskin Art Collection at the Oxford Drawing School. Ruskin heard from his old friend Rawdon Brown that Prince Leopold had been in touch with him, Brown, to ask him, as a friend of Ruskin's, to exhort the master to prepare a new edition of *The Stones of Venice*. According to Cook, once this information was relayed to Ruskin, he took it, from such a source, "as a command."[2] He promptly arranged a long stay in Venice for that very purpose. He left in August 1876, and did not return until the following June.

As before, he travelled without friends but took along a new servant, Baxter, He entered Venice on September 7, moved into the Grand Hotel, in the Ca' Ferro, staying there until February. At that time he decided the hotel was too expensive and transferred to the Calcina, a small inn on the Zattere, opposite the Giudecca. He remained there until he left the city on May 23, 1877. Friendships with Rawdon Brown and Edward Cheney were revived, though still, apparently, with some of the same mixture of feelings as before. "Mr. Cheney's sayings are very sweet and kind," says Ruskin, "who would ever think there was such a salt satire in the make of him."[3] With Brown things were rather smoother; they met often, and, as before, Brown was invaluable to Ruskin in his researches into Venetian history, lending him many of his books and manuscripts. Ruskin developed the habit, after the death of both parents,

of making any man even slightly older than himself into a father figure. Carlyle is the most famous example. Brown, too, now became ''Papa'' Brown in their correspondence, to his ''loving figlio,'' John Ruskin. The forms of address in their letters, besides telling us something of Ruskin's unusual emotional life, also give the modern reader an insight into the social formalities of an earlier era. Though Brown and Cheney are ''Rawdon'' and ''Edward'' to each other, Brown and Ruskin never, even after thirty years, addressed one another by their Christian names. Ruskin moves from the formal ''Mr. Brown'' to the more familiar ''Brown'' and then straight to ''Dearest Papa'' or ''My dear old friend.''

Though not generally noted for making friends or seeking out society, Ruskin was, during this winter, at the center of a large circle of pupils and acquaintances. This was due in part to his increasing fame and prominence. Charles Eliot Norton had supplied him with an introduction to Professor C. H. Moore, a colleague of Norton's at Harvard, where he became the first Professor of Drawing as well as the first Director of the Fogg Museum. He and Ruskin sketched and studied together, and went off on an expedition across the lagoons. He was also joined by another Oxford pupil, J. Reddie Anderson whom he set to work alongside himself studying and copying Carpaccio. Rarer occurrence, Ruskin also came to know one or two Italians. He spent time with two young Venetian artists, Angelo Alessandri and Giacomo Boni, the latter an architect and archaeologist whose work in the fields of restoration and preservation owe a great deal to Ruskin's influence.

It was through Signor Alessandri that Ruskin met Count Alvise Piero Zorzi, a member of the Venetian nobility who ran the Museo Civico Correr. Ruskin knew and admired Count Zorzi more than any other Italian he ever met, and he recorded his delight at meeting him: ''For thirty years I have been seeking a Venetian patrician—an artist—who would think and write about Venice and about St. Mark's as you have done, my young friend, and I am happy to have found you.''[4] Zorzi was, like Ruskin, intensely critical of the damage being done to his city's architectural heritage in the name of restoration, and had written a book protesting it. He did not, however, have the money to publish it, which Ruskin therefore provided. The work appeared as ''Osservazioni intorno ai ristauri interni ed esterni della Basilica di San Marco,'' in 1877, with a preface by Ruskin. As a direct result of its publication restoration work in progress was halted, and an investigatory committee in 1880 upheld Zorzi's and Ruskin's findings.[5] This is exactly contemporary with the first moves towards serious preservation in England, with William Morris and the Society for the Protection of Ancient Buildings. It is a strong indication of Ruskin's prestige in his adopted city, as well as of his great generosity in support of causes

he believed in. He had similarly stood behind Lorenzi and his Ducal Palace project with financial aid.

In addition to his perpetual and unrelenting campaign against the hand of the "restorer," Ruskin was busily occupied during this ten-month stay with projects both literary and artistic. Carpaccio had become the focus of his writings on Venetian art, and now absorbed Ruskin's attentions as had previously Turner, Tintoretto and Giotto. This is the time of his intensive study, amounting almost to a mania, of *St. Ursula's Dream*, which became known in Venice as "il quadro del Signor Ruskin." The picture was fused in Ruskin's mind with his memories of the dead Rose La Touche. On Christmas Day, 1876, he reported a dream in which images of the two females were united.[6] He referred to the picture itself as "my dear little princess,"[7] and even began to imagine that Rose's spirit communicated with him through the medium of St. Ursula. He drew actively during this stay, not only studies after Carpaccio, but many architectural subjects.

The literary productions of this Venetian visit were several. In 1877 appeared the *Guide to the Academy at Venice*, a work significant for being the first in which Ruskin had a full-scale opportunity to express his thoughts on Carpaccio, and for being the first to mark the distinct turn in Ruskin's writings towards the schoolmasterly. That movement was reinforced with the serial appearance of *St. Mark's Rest*, perhaps the most ambitious literary project of the 1876 stay. Many critics have found *St. Mark's Rest* one of Ruskin's least pleasing books. Certainly it is no worthy follower of *The Stones of Venice*, though Ruskin himself always liked to think of it as a continuance of that work. In fact, he believed that the newer work would supplant the earlier, and better answer his purposes, by giving greater prominence to the ethical interpretation of history. His tone is frequently querulous and occasionally mawkish. E. T. Cook, a staunch Ruskin defender, admits "much of it seems to be addressed to children of tender age,"[8] and the book must clearly be related to that side of Ruskin's genius which gave us *Ethics of the Dust*. Henry James called the various sections of the book "aids to depression,"[9] and George Eliot regretted that his "wrathful innuendoes against the whole modern world"[10] were so pervasive and intrusive. The very subtitle of the book should warn us of Ruskin's state of mind, that condition of depressed belligerence which infuses so much of his writing during the 1870s and 1880s: it is "The History of Venice, written for the help of the few travellers who still care for her monuments." The tone and structure of the book typify that schoolmasterly and admonitory voice that Ruskin had been developing of late years. It is partly a guidebook for tourists, partly an instructional booklet for students. Ruskin himself said that the material

in it was originally "meant for a lecture,"[11] doing for Venice what *Mornings in Florence* had done for that city. Cook again says of *St. Mark's Rest,* "the little red hand-books have been as familiar in Venice as the 'Mornings' in Florence." The repetitiousness which so often accompanies the didactic impulse is fully in evidence. *St. Mark's Rest* and the *Guide to the Academy* duplicate much material on Carpaccio which, one feels, the earlier Ruskin would have handled differently and presented in a more focused manner.

His other principal writing project during the 1876 visit is another product of Ruskin the educator. He was preparing a "Traveller's Edition" of *The Stones of Venice,* in which certain chapters were to be specially arranged and edited for the use of tourists and students. There was also to be a new index to buildings and quarters of the city intended to make the work more practical as an on-the-spot handbook.

Lesser literary projects of the time included the "Circular Respecting Memorial Studies of St. Mark's" sent out, at Morris' request, on behalf of the newly founded Society for the Protection of Ancient Buildings. Ruskin's introduction to Count Zorzi's book, a related item, has already been mentioned. He also had it in mind to produce a "Complete Guide to the Works of Carpaccio" at this time, for which notes can be found in the Library Edition,[12] but which was never completed. Also left unfinished was the treatise on Venetian coloring, to be called *Laws of Rivo Alto,* referred to in the previous chapter.

Before leaving the account of the literary productions of the period, mention should be made of those letters forming part of the *Fors Clavigera* collection that came from Venice during these months. They are of far greater interest and merit than any of the more formal works listed above. Indeed, in the intensity and immediacy of their prose they might with reason be considered the most remarkable literary fruit of Ruskin's association with Venice after *Stones* itself.

After this lengthy and industrious journey of 1876 it was to be six years before Ruskin again saw Italy. In the meantime, in 1880 *The Bible of Amiens* appeared, the distillation of his life-long attachment to the Gothic of northern France. It, too, is largely a guidebook and textbook in tone and structure, like the late Italian works.[13]

On August 10, 1882, Ruskin set off, on doctor's orders, with his valet Baxter and W. G. Collingwood, one of his chief disciples and later to become Ruskin's first biographer. After some time in Savoy and Switzerland they crossed the Mt. Cenis pass into Italy, arriving in Turin on September 23. Pisa was revisited, "here once more, where I began all my true work in 1845."[14] On September 30 they were in Lucca. It was in many ways an ideal journey from Ruskin's point of view, revisiting

many old and favorite haunts, yet also breaking some new ground. In the collection *Ruskin Relics* Collingwood has left his account of the journey, in two essays. The first, "Ruskin's Old Road," describes the start of the journey, with Ruskin "very much broken down in health, despairing of himself and his mission," and follows it through France and Switzerland. The Italian leg is covered by "Ruskin's Ilaria." Collingwood graphically describes Ruskin's fluctuating moods—elated by the Alps, depressed in Genoa. Once in Lucca, settled at the Hotel Royal, Ruskin lost no time in making a pilgrimage to the tomb of Ilaria di Caretto, venerated by him since 1845. He set Collingwood to work making drawings of it; and Collingwood gives us a picture of Ruskin himself at work: "He used to sit in quaint attitudes on his camp-stool in the square, manipulating his drawing-board with one hand and his paint-brush with the other; Baxter, his valet, holding the colour-box up for him to dip into, and a little crowd of chatterers looking on."[15]

It was increasingly important for Ruskin's worsened mental condition that he travel as a form of relaxation, and the teeming projects, literary and artistic, so much in evidence in all earlier journeys, are absent from this one, whether by Ruskin's own wish or at Collingwood's insistence. The letters and diary entries from Pisa for that September testify to Ruskin's erratic and unsettled mental condition; only two days after an entry like "a really happy day's work in Baptistery" we can find ourselves back in the midst of his bitter diatribes against the modern world and all its doings—"view of town from river totally destroyed by iron pedestrian bridge."[16]

In Lucca he received the sad news of the death of John Bunney, his former travelling companion and helpmate in Venice, at the early age of fifty-four. By October 8 he had moved on to Florence, chiefly important to him on this occasion for providing his first meeting with the Alexanders. Francesca Alexander, daughter of an American diplomatic family long resident in Tuscany, was to be the next in that distinguished chain of young ladies favored by the attention of the aging Ruskin. His friendship with her was, in Cook's words, "one of the pleasures and consolations of his later years."[17] He became "Fratello" to her "Sorella," and together they collaborated on an illustrated volume of Tuscan folk-tales, *Roadside Songs in Tuscany*.

He was back in Lucca once more by October 11, meeting there with the architect E. R. Robson to discuss plans for the projected St. George's Museum at Sheffield. He was actively drawing and painting, even though literary tasks were at present beyond him, and the brilliant sweep and assurance of a late watercolor such as "Looking down from Florence towards Lucca," 1882,[18] should warn us against assuming any rapid falling off of his talents as landscape artist. This was to be the last time that

Ruskin saw Florence, Lucca and Pisa. He set off for home on November 10. He seems to have collected no material for future lectures—the Slade series for the following spring was "The Art of England"—but he was by now turning over in his mind during this time in Italy one important literary project, his last, *Praeterita*.

Ruskin's final visit to Italy was also his final foreign tour of any kind. It took place from June to December 1888. He was travelling with Arthur Severn and working on the final sections of *Praeterita*, which was published in parts from 1885 to 1889. The last chapter was completed in the summer of 1889, after which Ruskin wrote nothing more. He had not been abroad at all during the six years between the previous Italian visit and this one, mainly for reasons of health. He had given up the Slade Professorship in March 1885, for the same reason.

At Abbeville in northern France Ruskin and Severn were joined by two travelling companions: Sydney Carlyle Cockerell, the art historian and museum keeper, and Detmar Blow, a young American architect. Blow stayed with the party all the way across France to Italy. They crossed the Simplon to Baveno, Milan and Verona. At Bassano near Padua Ruskin stayed with the Alexanders in their summer quarters for nine days,[19] afterwards calling them "among the kindest people in the world."[20] In Venice, where they arrived on October 6, they stayed at the Albergo Europa, where, according to Cook, "he struck visitors as very frail and somewhat vague in talk."[21] The Countess Pisani called on him and gave him a Venetian gold ducat for his museum. His old friend Signor Boni was now in charge of the restoration work on the Ducal Palace, of which Ruskin much approved. The memories and associations of Venice, rich with half a century of experience, by no means all pleasant, sometimes proved too much for him. He wrote to Signor Alessandri that he could not hope to conquer the pressing signs of his illness "but by getting away from the elements of imagination which haunt me here."[22] Accordingly, by the end of October he was on his way back to Switzerland.

In Paris on the homeward journey Ruskin was seized with a severe attack of his illness. Joan Severn rushed to join them, to nurse him and take him home to Brantwood. He rallied somewhat from this attack, and was able to resume work on *Praeterita*, until a relapse in August 1889 incapacitated him from all intellectual effort for the remainder of his life, eleven years of it, during which time he never left his home.

Though this final journey to Italy, in so many ways a sadly feeble echo of earlier ones, saw no literary activity beyond the continuation of the autobiography, one rather important event in Ruskin's life did take place during it, an event curiously absent from most accounts of his life

and consequently little known. He proposed marriage. He did so by letter from Italy, and the recipient was Kathleen Olander. Ruskin had met her, a teenaged art student at the Bedford Park Art School, in 1887, while she was copying in the National Gallery. In the by now inevitable way with young ladies, she soon became his "pet" and he her "Maestro." He gave her much good professional advice on her copying and, according to the editor of their correspondence, presented her with copies of his *Elements of Drawing* and *Laws of Fésole*.²³ Not surprisingly, Miss Olander's parents became alarmed when Ruskin's more intimate intentions transpired, and this, coupled with Joan Severn's determination that Ruskin should not again become entangled in an affair like that with Rose La Touche, effectively quashed the relationship. It says something about Ruskin, and in retrospect about his marriage to Effie, that he saw no incompatibility between the roles of pupil and of wife.

Readers of the *Collected Works*, of E. T. Cook's *Life*, and of many another book on Ruskin besides, may wonder why no mention is made of Kathleen Olander, and why none of Ruskin's letters to her appear. The story is interesting and instructive. E. T. Cook, early biographer and tireless editor, knew of the existence of Miss Olander, of the part she played in Ruskin's life, and of the letters he wrote to her. He asked to be allowed to read those letters, and she generously complied. For whatever reason, Cook decided they showed Ruskin in an unacceptable light, and made her a less-than-generous offer in return. If she would destroy the letters he would mention her in the official biography; if not, all reference to her share in Ruskin's life would be omitted. She refused to destroy them, and so existed in a curious biographical limbo until their publication in 1953. Stories such as these mar the integrity and diminish the usefulness of so many of the early lives and studies of Ruskin, even of the awe-inspiring edition of the *Collected Works* itself; they also explain why, despite the dauntingly voluminous bulk of primary and secondary material, Ruskin scholarship continues.

Conclusion

In the Preface an attempt was made to place the present work within the context of existing Ruskin scholarship. It might be well, in summary, to review the particular contribution of this paper, and clarify what it offers the Ruskin reader.

Catalogues have their uses, and now for the first time a complete chronological compendium of Ruskin's Italian journeys, with dates and itineraries, is available. There is a deeper purpose, though, to following Ruskin through Italy. Famous lives, by the time they have accumulated several biographies and studies around them, tend to become excessively pigeon-holed and categorized. Once a "pattern" to the life has been established its neatness and convenience seem irresistible, future critics and biographers follow it, perpetuating and codifying it. Thus the "pattern" becomes a Procrustean bed which all the facts of the life must be forced to fit. A striking example of this is the 1862 trip to Italy, frequently ignored by Ruskin commentators, apparently because at that time Ruskin was "supposed" to be interested in social reform, not in Italian art. Following a specific thematic thread helps to break through these rigid compartments.

The early imaginative background of Ruskin the traveller has until recently received little close attention. The books by Tim Hilton and Elizabeth K. Helsinger tell us most. Studies of the eighteenth-century picturesque, and the methods of sightseeing and of connoisseurship taught by that tradition, are more relevant to an understanding of Ruskin than has been realised. It is a point which extends beyond Italy, of course, being equally central to Ruskin's response to Switzerland, or the English lakes.

Studying Ruskin in Italy can leave one in no doubt that the importance of Rawdon Brown in his life has been consistently underestimated, due, in large part, to the fact that their correspondence is unpublished. If it ever sees the light of day then Brown, and to a lesser extent Cheney, must have more significant roles in any future full-scale biography.

The pattern of "discoveries" associated with so many of Ruskin's visits to Italy is of the greatest significance, and can be read internally as well as externally. Externally, these "discoveries" tell us much about Ruskin's career and his place in the Victorian art world, for a "discovery" by him, given his enormous prestige, had repercussions on all levels: on his followers and disciples, obviously, but also on public taste and policy, as in questions as to what galleries should be spending their money on, and in the popular philistine press, too, in knowing what ought to be ridiculed. Internally, these artistic "discoveries" always accompany changes in Ruskin's attitudes and opinions in non-artistic areas. There must surely be a connection, and a close one, between the see-saw of Ruskin's alternating tastes, and the cyclical fluctuations of mood first noticed by Wilenski and the basis of his manic-depressive hypothesis—an hypothesis that has been generally accepted by later writers, though not without the occasional challenge. The present work has not seen the need to enter the psychoanalytic lists. Whenever Ruskin's mental state is a significant factor in his writing, as for instance with the Rose La Touche/St. Ursula confusion, it is so patent as to call for little psychological speculation.

Too many books on Ruskin have an axe to grind, that is to say a particular "view" of Ruskin to promote—Ruskin the aesthete, Ruskin the manic-depressive, Ruskin the Father of British Socialism, and so on. The technique adopted here, of following a theme rather than promoting an interpretation, breaks through the usual categories and permits fresher insights into a writer as rich in complexity as he is rich in reward.

A Chronology and Geography of Ruskin's Italian Journeys

1833: The first of the Ruskin family tours abroad; also the first time any of them saw Italy, including the fourteen-year-old John. They left England in May, travelled down the Rhine to Switzerland, crossing the Splügen Pass into Italy. They stayed at Cadennabia and Como in the Lakes, moving on through Monza to Milan and Genoa. Plans for Rome were abandoned, so they turned back through Switzerland and France for home by the beginning of the autumn.

1835: The second family tour, longer than the first, lasting from June 2 to December 10. They again spent some time in the Alps before entering Italy. Most significantly, this visit included time in Venice, where they spent six days.

1840/41: The third family tour, and the longest so far. This time there were concerns about John's health, so he was removed from England for the entire winter. They were away from September 24, 1840, until June 29 of the following year. They were again in Genoa, and saw Carrara for the first time. This was also Ruskin's first time in Lucca and Pisa, towns more crucial than any others, save Venice, for his future architectural writings. Florence was visited, and disliked, followed by four days in the hill towns of Siena, Radiocofani, and Viterbo on the way to Rome, at last. By January 9, 1841, the Ruskins were in Naples, staying until March 17, when they returned to Rome. April 18 saw them in Bologna, and by May they were in Venice, where they stayed this time for eleven days.

1845: Ruskin's first time in Italy without his parents. He left England on April 2, accompanied by his valet, John Hobbes. They later met with Couttet, who acted as courier. They entered Italy not through the Alps but along the Riviera coast, through Massa and Carrara, arriving in Genoa

on April 26, and spending three days there. Three months were devoted to Lucca, and six weeks to Florence, where Ruskin found more to interest him than he had previously. They spent four days each in Parma, Piacenza, and Pavia on the way north to Baveno on Lake Maggiore. Then, through Como, Bergamo, Desenzano, and Verona they made their way to Venice, settling there for five weeks before returning home in October.

1846: The three Ruskins on the road again, John wanting to show his parents the finds of the previous year. The departure date was again April 2, and again the return was in October. They were visiting the Cathedral at Como on May 7, and three days later were in Verona. By May 14 they were once more established in Venice, the focus of the trip, though excursions were taken to Florence, Lucca, and Pisa.

1849/50: The newly married John and Effie arrived in Venice in November, having travelled by way of Geneva, the Simplon Pass, the Borromeo Palace at Isola Bella, Milan, and Verona. After this, the excursion becomes a stay rather than a journey. They remained in Venice until the following summer, Ruskin gathering material for *The Stones of Venice*, travelling only within the city and the islands of the Lagoon until their return home.

1851/52: The second stint of Venetian research lasted from September 1, 1851 until late June 1852. The journey down appears to have been a repeat of the previous one, suggesting again the practical rather than sight-seeing motivation.

1858: Ruskin was single again, absent from Italy for six years, during which time he had made two Swiss visits with his parents. They were not with him on this occasion. He crossed the St. Gothard to Bellinzona at the beginning of June. He spent the rest of June and early July on the Italian Lakes, at Locarno, Baveno, Isola Bella. He arrived by train in Turin on July 15, and stayed there until August 31. It was during this time that the visit to the Waldensian Chapel took place. He ventured no farther into Italy, not revisiting Venice, Lucca or Pisa.

1862: This was a brief visit, only to Milan, made with the Burne-Joneses. They left England on May 15 for Switzerland, and crossed the St. Gothard to Milan. Ruskin's work for the summer centered on Bernardino Luini, particularly the frescoes at San Maurizio in Milan. He was on his way home by early September.

1869: Ruskin was now ready to see Venice again, after seventeen years. He was in Verona by May 8, where he received the offer of the Slade Professorship. It was on the homeward journey from the summer spent in Venice, at Lugano on August 14, that he heard of his election. In Venice he had found Carpaccio.

1870: Ruskin now resumed more regular visits to Italy, partly to gather lecture material. He left on April 27, with a much increased retinue. They arrived in Milan on May 20. Five days later they were in Venice, spending about a month there. By late June they were seeing Pisa and Florence, then Siena before leaving Italy on July 7, their departure hastened by the outbreak of the Franco-Prussian War.

1872: On April 13 Ruskin again set out for Italy with much the same party. They went this time by way of Geneva to Genoa, and were at Lucca and Pisa by April 27, staying there until March 8. They then headed south, spending three days in Florence before arriving in Rome on May 12. From Rome they wandered through the hill towns of Assisi, Perugia, Siena, and Orvieto, getting to Venice by June 23. They settled there for three weeks before returning to England by way of Milan, Como and the Simplon, arriving home by the end of August.

1874: Ruskin left at the end of March for a seven-month visit to Italy. On April 9 he wrote home from Pisa, and then moved on to Assisi, the chief object of this journey being the Giottos at San Francesco. But before setting to work there he made a southward progress through Rome and Naples, and then, for the first time, travelled south of Naples, taking up an invitation to visit Palermo. By early June he was back in Rome, then on to Assisi where he settled for several weeks. On his way north he stopped at Lucca, and spent a month in Florence.

1876/77: Venice was the objective of this trip, Ruskin having it in mind to bring out a revised *Stones*. He left in August 1876, and was away until the following June. He travelled with a new valet, Baxter, and entered La Serenissima on September 7. He renewed old acquaintances, especially with Rawdon Brown, and became deeply involved in the city's restoration/preservation issues. He left on May 23, 1877.

1882: Ruskin left England in August, again with Baxter, and with W. G. Collingwood, his first biographer. They spent time in Savoy, crossed the Mt. Cenis, and arrived in Turin on September 23. A week later they were in Lucca. Collingwood described this journey in *Ruskin Relics*. On Oc-

tober 8 they were in Florence meeting the Alexanders. It was to be Ruskin's last time in Florence, Lucca, and Pisa. They were on the way home by early November.

1888: The last visit to Italy and his last trip abroad. It lasted from June to December. Ruskin was travelling with Arthur Severn, and they met various artist friends on the way. They crossed the Simplon to Baveno, then moved on to Milan and Verona. They stayed for nine days with the Alexanders at Bassano, near Padua, and arrived in Venice on October 6. The memories and associations of Venice proved too much for Ruskin, and in Paris on the homeward journey he was taken with the first of the series of attacks of insanity which incapacitated him from all work and all travel for the remainder of his life.

The John Ruskin/Rawdon Brown
Correspondence

The correspondence between Ruskin and Rawdon Brown in the British Library, covering the years 1850 to 1881, forms a biography-in-miniature of Ruskin's most creative years, and offers direct background on several publications. Most of what was said about Rawdon Brown in chapter 4 is based on this source. Some readers, perhaps, will want to know about the correspondence in more detail, and since it is unpublished, this appendix is offered, summarizing the letters chronologically and in detail, quoting from them where helpful.

It is interesting to trace various themes running through the correspondence: the interchange of scholarly materials and ideas between the two men; Rawdon Brown's role as Ruskin's agent in Italy; Ruskin's tremendous generosity in support of causes he believed in, a generosity certainly taken full advantage of, if not actually abused; recurring problems with health; hints of the "crustiness" on the part of Brown referred to in the *Times* on the occasion of his death.

The first letter is sent by Ruskin from Denmark Hill, April 23, 1850, and is addressed to Brown at the Casa Businello, the first location Ruskin knew him and visited him in. From this first surviving letter it is already clear that Ruskin is using Brown to further his Venetian researches: "I cannot enough express my thanks to you, or to Sr. Vason—both for the choice and execution of the drawings, the subjects being—all but the waterdoor—entirely new to me—and your crested Morosini door quite invaluable—hardly less so the chair ornament—of which I have not a single instance." Vason was the artist employed to make these designs, the "careful verity" of which Ruskin praises, wondering if 100 francs is sufficient recompense for the work, and asking Brown to act as his agent in the matter. Ruskin requests further drawings of the same sort. Brown clearly allayed Ruskin's fears over the financial question in his reply, and

Ruskin's next letter again says "I do thank Sr. Vason for drawing honestly and carefully." This letter is interesting, too, for being the only one to carry an appended note from Effie.

On September 21 Ruskin again writes from Denmark Hill because "two things have just come up that I need Vason's help in quickly." He wants "a very slight profile—merely a line—of the base of a fragment of house at the Ponte St. Cristoforo-Calle Barbaro, near la Salute." This shows just how specific were Ruskin's researches in his determination that none of the stones of Venice should remain unturned. He adds requests for further drawings, including sketches to show precisely what it is he wants. Again Ruskin worries what Vason should be given.

These letters are, of course, from the period when Ruskin was collecting material for *The Stones of Venice,* and indicate his dependence upon artists on the spot, and upon Brown to handle them for him. There are no more until 1857, when Ruskin, though he writes still to "Dear Mr. Brown," now feels comfortable enough to philosophize in letters to him. He says how touching he finds human nature in the gratitude it shows for the smallest kindness, quoting a couplet from Wordsworth to that effect, though saying at the same time that he knows Rawdon Brown is not fond of Wordsworth—perhaps an interesting conflict of tastes between the romantic Ruskin and the old-style eighteenth-century gentleman. After the exertion of *Stones,* Ruskin comments, "I am recovering my sense of enchantment about Venice—but very slowly." The familiar note of disenchantment with the modern world sounds: "I think I shall just send you a word of kind wishes now & then—not pretending to be a letter—I find it is no use waiting—in this world of steam and speed, till one has 'time' to write letters."

There is another six-year gap until the letters resume in 1863. They go far towards explaining the mysterious mid-life absence from Venice. On January 3 he writes to Brown: "How often I have been going to write to you—perhaps Heaven knows: I don't. I *did* write once. The letter was full of somewhat cheerful talk about a plan I had—the plan came to naught & the letter was burnt." He goes on to describe his present life in Mornex, Haute Savoie: "settled here in great quiet—with books." He says he plans to build a house deeper in the woods, but is presently living in the village, "with a fair view south over the glaciers, and a sunny slope of limestone crag above, and Geneva accessible in a forenoon's walk." The next March he writes from the same place, voicing the mood of gloomy depression behind his self-imposed exile in the Alps: "I am a little better but I cannot keep my eyes and ears shut: and how is one to eat one's dinner in peace—in this wretched world." He also mentions "some nonsense of mine, which may make you laugh a little," appearing in *Fraser's Magazine*:

"I laughed a little over it myself and am little given to laughing—so I hope it's laughable." He is referring, of course, to *Unto This Last*. By the time of this letter, Rawdon Brown is being addressed at the Casa della Vida, where he remained for the rest of his life.

The next letter is sent from Geneva and dated April 7, 1863. Ruskin is frightened by something Brown had previously said about the state of his eyes—"you know it will never do to overwork them." He advises him to rest for two or three months from his work on the calendars, and "read nothing but large print." He then mentions his plans for Venice, telling Brown that he would like to visit in the coming September, around September 15, and asking: "I wonder what would be the cost of a little bachelor's den, for a permanency of cupboard to put things away in— with a marble balcony to the window—somewhere on the grand Canal or in the Ponte de' Sospiri quarter." But he adds that he should not be overmuch in Venice, "my health requiring hill air." He also asks in this letter about "Lorenzi's documents," and whether or not they will be published—shortly to be a major theme of the correspondence.

Ruskin was still in Geneva on October 12, 1863, when he next wrote to Brown. In that letter he explains that business has detained him in Switzerland, forcing him to abandon his plans for Venice. However, he says he will definitely be there in the spring. This delay in his own arrival, he stresses, must not disturb their Lorenzi plans, and he asks to be told "as soon as his book is in order," to consider whether it should be published in London or in Venice. Lorenzi was a Venetian antiquarian who became sub-librarian at the Ducal Palace, and whose chief work, done under Ruskin's patronage, was a documentary history of that institution. Ruskin then explains what the "business" is that has detained him. It "was—and still is—the securing possession within assignable limits, of a piece of pasture and forest in Chamouni—the map—dating from 1720 or thereabouts—torn all to pieces, and the peasants generally preferring to go to law with each other, to paying for a new survey and map." He concludes this letter with an interesting piece of self-knowledge concerning his growing melancholy, saying that he stays in Switzerland to recover "from the astonishment of despondency which had stunned me," adding, "I believe the chronic and intense anger in which I live wears me out and poisons my blood."

Ruskin is still receiving packets of drawings and daguerreotypes from Rawdon Brown, for one of which he thanks him in a letter dated October 24, 1863. He says that he has heard from Lorenzi, but has not yet made much of his letter, "knowing no more Italian than I did 20 years ago"; he is able to deduce, though, that Lorenzi needs money for his project, and so he sends along £100. He is most happy to be of use to

Lorenzi "and to the Ducal Palace." From London on January 14, 1864, he again assures Brown that Lorenzi "can have more funds whenever you want them." Four days later Ruskin is at his desk again to thank Brown for more Venetian material: "Your documentary discoveries are most precious to me," while he himself sends Brown some books on Venice.

The recent materials Brown has sent are apparently concerned with the authenticity of a certain painting by Titian: "I do not think Titian would ever sign in that place, or way, and am certain the *greater part* of the work on the limbs is modern—and that *every* part has been gone over by the retouchers." A certain Ponti has now replaced Vason, and early in February 1864, Ruskin commissioned Brown to ask Ponti to let him have "anything and everything he can get from Titian, Tintoret, Veronese, Cima, or the Bellinis."

Lorenzi, it seems, continues optimistically to write to Ruskin in his native language: "would you kindly tell Lorenzi with my sincere regards that I can't read Italian nor Latin now without labour." The mention of effort takes him on to his health: "I cannot read anything that costs me the least labour—it brings on headaches and pains in the *teeth* and jaw— so there's no hypochondriacism in the matter. This horrible writing is all owing to my not putting any energy into my hand. I have steadiness enough when I choose; but it tires me to write thus." The handwriting of this letter is indeed sadly deteriorated.

On February 5 he acknowledges receipt of another Lorenzi packet— "how superb and interesting they are!", and again he asks Brown to tell him how much money to send.

A letter of March 14, 1864, deals with the death of his father, which had occurred eleven days earlier. Two quotes from it tell us much about Ruskin's attitudes towards both parents, and about his feelings, at this time, for his childhood religion:

"There was much that was peculiarly painful to me in this speechless and even doubtfully perceiving death; for all our lives there was an incapability between my father and me of understanding each other at the right time—which seemed all to collect now into one consummation of helpless and useless affection in both."

"My mother, though she had only my father and me in this world to care for, is both in her own nature and her acquired faith (very serviceable on such occasions, however untrue) better able than I to stand against the shock."

On September 2, 1864, Ruskin is still as generous as ever in support of Lorenzi's project: "as soon as he wants more money it is unlimitedly and instantly at his service."

On October 23 he thanks Brown for a roll of Giotto photographs which have arrived safely and with which he is very pleased, though he adds, "I have passed by the school now, and care only for the later men."

By the start of 1865 Ruskin has apparently seen the first proofs or galleys of Lorenzi's work, and he instructs Brown to 'tell him I have his letters and think the book-sheets lovely." By these last words *foglie carine* has been written in the margin, presumably by Brown for Lorenzi's benefit when showing him Ruskin's letter. One notices that despite Lorenzi's attempts to write directly to Ruskin, Ruskin never sends word to him except through the medium of Brown.

On February 23 Ruskin thanks Brown for more Titian material and sends more money for Lorenzi. Brown's reply, dated March 17, 1865, has found its way into the collection, along with half a dozen or so others: "Your letter of the 23rd Febr. was most satisfactory, and gave Lorenzi great heart and spirits." Does that "most satisfactory" have a slightly chill and condescending feel?

It is nine months before Ruskin writes again, and on December 18, 1865, he apologizes for the delay. He has been busy, and sends Brown a copy of his latest book to prove it—probably *Ethics of the Dust*. He says he has had a number of communications from Lorenzi lately, "very full of pretty sayings, which I can't read," but of one "I made out the gist to be that he wanted some more funds." Ruskin dutifully sends along another £40, but now asks Brown, "could you now get some notion of the limit he means to touch, for me?" His fears on the subject are apparently allayed for a year at least, for in a letter dated January 4, 1867, he assures Brown, "Pray let the book be continued as long as Lorenzi and you think it useful. I am not going to make it a deficient or unsatisfactory work for the sake of another 50 pounds." Six months later comes a delayed answer to the original question, dated July 28 from the Casa della Vida. Brown apologizes for the long delay, explaining that he had been much upset of late by the death of Henry Cheney, elder brother of his good friend Edward. He also wished to put off answering Ruskin's question about future funds because Lorenzi "had hoped to get on without (indiscreetly goading his patron) (erased) encroaching further on your goodness." However, Brown now feels duty bound to voice "a suspicion that the wheels are clogged." He explains that Count Dandolo, Keeper of the Archives, recently died, and that "this event has subjected Lorenzi to much loss of time." He ends by reassuring Ruskin of Lorenzi's continued zeal in his cause, and suggests ways in which money may be more smoothly transferred.

On August 4 Ruskin replied from Keswick in the Lake District, with a letter of condolence on Brown's loss. "The specialty of your fitness for each other—and the separation of you both by many marked points of

character from the generality of men, must make it rending rather than loss—the tearing away of a part of yourself.'' It is clear that Ruskin has mistakenly thought it was Edward who died. He includes another £50 for Lorenzi, ''but I think I must ask Lorenzi to wind up when this is exhausted. Please say to him I am quite sure no money could have been better spent—or more carefully used.'' Six days later Brown replied, chiefly to correct Ruskin's misconceptions over the deceased: ''Edward, whom you knew, has passed the last two months with me,'' recovering from the blow of his brother's death.

A whole year passes before Ruskin writes again, from Abbeville, on September 20, 1868. He explains that he had not written because he kept meaning to visit Venice: ''I entirely purpose being at Venice next spring— (but I had as entire purpose of being there this autumn—and last winter— which has nevertheless been broken).'' He adds that an English artist of his acquaintance will soon be in Verona doing some work on the Scaliger Tombs for the Arundel Society; he has furnished him with Brown's address for any assistance he might need.

Brown replies on October 4 to say that Mr. Bunney, the artist mentioned, had presented himself, and that he had helped him to find accommodations.

There is now a three-year gap in the correspondence. During that time Ruskin had been in Venice three times, in May 1869, May 1870, and June 1872. It is likely that he saw much of Brown during those stays. Certainly, correspondence with him resumes very shortly after his return from the last of those three visits, on July 31, 1872, when he asks ''Can you point me to any source for some detail of the life of the Venetian Jacopo Cavalli.'' Clearly Ruskin's researches into Venice continued.

There is another gap in the correspondence, and by the time it resumes, in August 1875, Brown has become ''My dearest Papa'' to Ruskin's ''loving Figlio.'' Whatever psychological or emotional shift this implies, the letters continue to have scholarly interchange as their chief note. Brown sends Ruskin a volume of Venetian history, saying ''When first I came to Venice in 1833 the work was recommended to me by the dear old librarian of St. Mark's Don Pietro Bettio.''

By the beginning of 1877 Ruskin is sending Brown proofs of *St. Mark's Rest*, presumably the work for which the earlier references were needed: ''Nobody has seen this proof yet—your eyes are the first. I weary with it.'' And, ''On your eyes be it: For if I had not come to Venice to see *you*—undutiful figlio as you think me, not a word of this would ever have been written.'' At the same time the revised edition of *Stones* is nearing completion. Two remarks about Edward Cheney sum up that particularly thorny relationship: ''Cheney's sayings are very sweet and kind,''

(presumably sayings about Ruskin's recent publications, as relayed by Brown, and, if relayed accurately, very much at odds with Cheney's other reported opinions on Ruskin) "who would think there was such a salt satire in the make of him." Later, "What a lazy boy he is—why doesn't he write a history of Venice?"—probably not a remark to endear him to Cheney. In similar vein, in a letter of a month or two later, he comments, "His satire, surely is one of his chief gifts—he seldom speaks without a sparkle of it in his eyes."

A letter of March 1, 1877, has the following: "My sleepless night was partly owing, though I do not say so in Fors, to a letter I opened just as I was going to bed, containing Mr. Bentinck's lecture at Whitehaven: in which I think he does equal discredit to himself and to me: and which happens to be especially inopportune by coinciding with attacks made by other reviews on my friend Henry Acland at Oxford, while I am here and unable to defend him." This is interesting in that it shows how Ruskin threw himself into the "pamphleteering" aspect of *Fors Clavigera* and his other journalism—the "Savage Ruskin" of the popular rhyme—and also because this is presumably the same Mr. Bentinck, Cavendish Bentinck, who ultimately became Brown's executor and left this very collection of correspondence to the British Library.

Their scholarly exchanges continue: "These are delightful books on Verona you have sent me; and I shall look with extreme interest for anything you have to tell me about Othello." In March 1877, they are corresponding over the question of whether or not to translate Italian Christian names into English—"nor do I wish to speak of James Tintoret, though I say frankly—Paul Veronese." Other letters of that month ask Brown for the "exact date of the death of John Bellini," and thank Lorenzi for some "details" valuable for an appendix—in all likelihood for the forthcoming *Guide to the Academy.*

A letter dated March 22, 1877, continues such questions—what was Tintoretto's death-date, what was the Carità Institution, and so on. It also shows a certain level of rivalry and bitterness beneath their friendly exchange. The two of them had obviously had some disagreements over the revised edition of *Stones*, (those letters seem not to exist) and Ruskin asks "What did you fetch me to Venice for? To repent of the Stones, instead of to reprint them?" Brown has written in the letter's margin, "I fetched you to Venice to reprint the 'Stones' & to correct their errors, not to add to them." One begins to understand those references to "crustiness" in the *Times*, September 8 and September 13, 1883.

The same kinds of footnote questions continue through March, April and May 1877, when Ruskin was himself in Venice, sending brief notes from his own lodgings to Brown. He borrows Brown's copy of Reynolds' *Discourses.*

By the end of the summer Ruskin was back at Brantwood, and by April 1878 writes the following: "I've been as mad as a March hare all March—and an April fool all April—what the May moon may make of me—heaven knows"—a charmingly but deceptively flippant handling of problems which, to judge by the deteriorated hand for these months, must have been very real. "I'm not allowed to write," he adds, "but *do*, on the sly."

On August 6 Brown writes to thank Ruskin for copies of *Deucalion* and *Laws of Fésole.* These works, he says, "seem to me written with such free use of all the senses"—perhaps trying to allay their author's fears of his dwindling powers.

Each of them executed, during this year, a social introduction on behalf of the other. In July Ruskin met "the Countess Pisani's young friend, and was much pleased with him and have made an appointment for Friday at the National Gallery." In September Brown received John Simon, an artist friend of Ruskin's, and his wife in Venice, and tried his best to be hospitable, but "as Mrs. Simon does not believe gondolas to be safe and seaworthy, my suggestions about sightseeing were not of much use." He did, however, succeed in lending Mr. Simon *St. Mark's Rest* on a visit to San Giorgio de Schiavoni, "that he might enjoy the Carpaccios there."

Ruskin's letter of December 17 thanks Brown for his kindness to the Simons, and rather poignantly describes his own activities: "Remaining quiet—and amusing myself with flowers and stones. Things come into my head about them which I can still say clearly—but I can't do any Venetian history or English politics." Ruskin's artistic subject-matter has come full circle from those early trips as a teenager through the Alps drawing the local flora and studying rock formations.

Their letters continue for three more years, with more details of Venetian history, more daguerreotypes of bas-reliefs, until the end. But they become more sporadic, both parties suffering increasingly from poor health, Brown's physical, Ruskin's mental. The death of Carlyle in 1881 prompts Ruskin to contrast the "benevolent and happily retrospective life" of Rawdon Brown with the "bitter and scornful misery of Carlyle's," to which Brown replies, "the dreariness of life without its 'fond memories' has always impressed itself on me." Rawdon Brown died on August 25, 1883.

Two Italian Poems

Because Ruskin's poems are quite unfamiliar to most readers, two on Italian subjects are here included. They are of interest on several levels. They form, firstly, one of the creative responses of Ruskin to Italy, a less familiar one than his prose writings or his drawings. In their style and imagery they tell us much about the imaginative background Ruskin brought to Italy, as dealt with in chapter 1. They also provide fascinating hunting-grounds for influences and analogies, being curiously transitional. Take the first stanza of "The Hills of Carrara"; it, surely, in its rhythms and cadences, is very old-fashioned for 1840; the echoes are of Gray and Collins. Yet, to the present reader's eye and ear at least, those images of the spreading vine and the bright birds in the myrtle copse are irresistibly suggestive of a Pre-Raphaelite painting, by Millais, perhaps, or Arthur Hughes.

Ruskin's poetry is amassed in Volume 2 of the *Collected Works*. The great majority of it dates from before 1845. Poetry was principally an activity of Ruskin's youth; he won the Newdigate Poetry Prize while at Oxford for his "Salsette and Elephanta." The Newdigate has occasionally been won by men who have gone on to distinguished careers as poets; more often it has been won by men for whom, as for Ruskin, poetry was an undergraduate activity.

Poetry as a form of self-expression for Ruskin was supplanted by others. As soon as his drawings and his prose writings developed their mature creative vocabularies, he seems to have felt the need for verse no longer.

"The Hills of Carrara" can stand as a good example of the picturesque taste in its landscape mood. It is nature painting, searching for verbal counterparts for the visual experience; in fact, the *Collected Works* prints a contemporary Ruskin drawing of the same hills alongside the poem, to drive home the *ut pictura poesis* point. The first three stanzas are essentially descriptive. The last two ruminate upon the philosophical impli-

cations of the scene, the other important aspect of picturesque contemplation, and again not very different from what goes on in an ode of Collins, or in Gray's "Elegy."

"Venice" is an example of the picturesque in its more literary mood. It abounds with echoes of Byron, Rogers, and Mrs. Radcliffe. It is also closely related to that aspect of Ruskin's creativity which gave us "Marcolini," the early tragedy mentioned in chapter 1, which is also to be found in Volume 2 of the *Works*, for the *truly* devoted Ruskinian who wishes to explore this little-known by-way of the master's genius.

The Hills of Carrara (1840)

I

Amidst a vale of springing leaves,
 Where spreads the vine its wandering root,
And cumbrous fall the autumnal sheaves,
 And olives shed their sable fruit,
 And gentle winds and waters never mute
Make of young boughs and pebbles pure
 One universal lute,
And bright birds, through the myrtle copse obscure,
Pierce, with quick notes, and plumage dipped in dew,
The silence and the shade of each lulled avenue,—

II

Far in the depths of voiceless skies,
 Where calm and cold the stars are strewed,
The peaks of pale Carrara rise.
 Nor sound of storm, nor whirlwind rude,
 Can break their chill of marble solitude;
 The crimson lightnings round their crest
May hold their fiery feud—
 They hear not, nor reply; their chasmed rest
No flowret decks, nor herbage green, nor breath
Of moving thing can change their atmosphere of death.

III

But far beneath, in folded sleep,
 Faint forms of heavenly life are laid,
With pale brows and soft eyes, that keep
 Sweet peace of unawakened shade;
 Whose wreathed limbs, in robes of rock arrayed,
Fall like white waves on human thought,
 In fitful dreams displayed;
Deep through their secret homes of slumber sought,
They rise immortal, children of the day,
Gleaming with godlike forms on earth, and her decay.

IV

Yes, where the bud hath brightest germ,
 And broad the golden blossoms glow,
There glides the snake, and works the worm,
 And black the earth is laid below.
Ah! think not thou the souls of men to know,
 By outward smiles in wildness worn:
The words that jest at woe
 Spring not less lightly, though the heart be torn—
The mocking heart, that scarcely dares confess,
Even to itself, the strength of its own bitterness.

V

Nor deem that they, whose words are cold,
　Whose brows are dark, have hearts of steel;
The couchant strength, untraced, untold,
　Of thoughts they keep, and throbs they feel,
　May need an answering music to unseal;
Who knows what waves may stir the silent sea,
　Beneath the low appeal,
From distant shores, of winds unfelt by thee?
What sounds may wake within the winding shell,
Responsive to the charm of those who touch it well!

Venice (1835)

The moon looks down with her benignant eyes
 On the blue Apennine's exulting steep;
Many a large star is trembling in the skies,
 Lifting its glory from the distant deep.
How high the marble carved rocks arise,
 Like to a lovely thought in dreamy sleep!
Along the weedy step and washen door
 The green and drowsy surges, moving slow
Dash on the ancient, tesselated floor;
 Or still, and deep, and clear, and coldly flow
Beside their columned banks and sculptured shore;
 Or waken a low wailing, as in woe,
Where sleeps beneath the unbetraying water
The victim, unrevenged, of secret midnight slaughter.

The palaces shine paly through the dark,
 Venice is like a monument, a tomb.
Dead voices sound along the sea; and hark,
 Methinks, the distant battle's fitful boom!
Along the moonlit pavement of St. Mark
 The restless dead seem flitting through the gloom.
There, melancholy, walks—the Doge's crown
 High on his gleaming hair,—the warrior grey.
How passionless a chill has settled down
 Upon the senator's brow! A fiery ray
Gleams underneath the bravo's stormy frown!
 Who long ago have vanished, awake,
Now start together from the various grave,—
Live in the silent night, and walk the conscious wave.

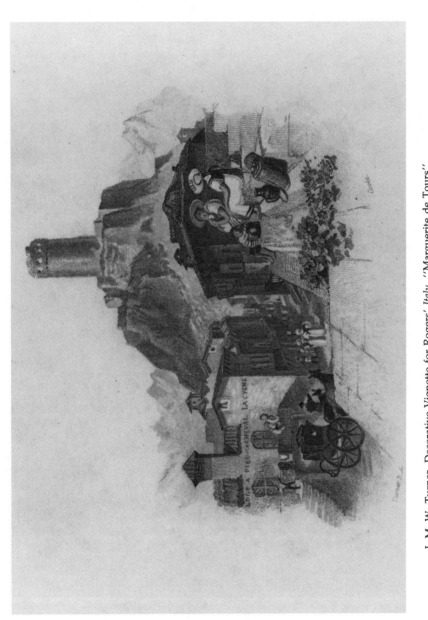

J. M. W. Turner, Decorative Vignette for Rogers' *Italy*, "Marguerite de Tours"
Published by T. Cadell, London, 1830.
This vignette illustrates the verse tale of "Marguerite de Tours," a disconsolate Alpine maid (*Italy*, pp. 25–28). In style and structure it suggests Ruskin's 1858 drawing of Bellinzona.

J. M. W. Turner, Decorative Vignette for Rogers' *Italy*, "A Farewell"
Published by T. Cadell, London, 1830.
The illustration for "A Farewell" shows Lake Como from the Borromeo Gardens
(*Italy*, pp. 233–36), and typifies Ruskin's early, picturesque response to the Italian
Lakes. In fact, Ruskin singled this picture out for special tribute.

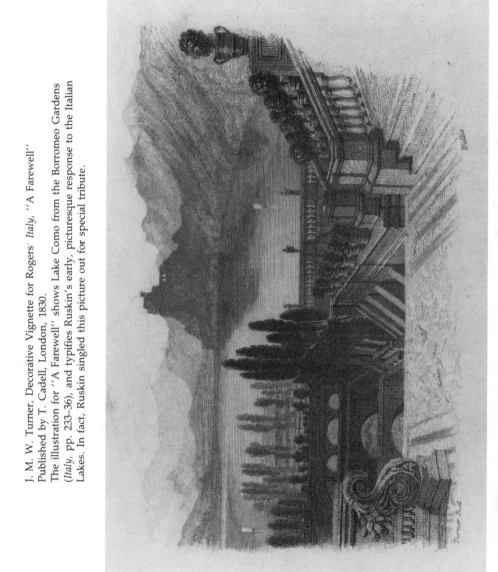

Thomas Stothard, Decorative Vignette for Rogers' *Italy*,
"The Fountain"
Published by T. Cadell, London, 1830.
"The Fountain" is one of twenty illustrations Stothard provided
for the poem (*Italy*, p. 175). Stothard's vignettes generally are
figure scenes, while Turner's are landscape and architectural views.

John Ruskin, *Bellaggio, Lake Como*, 1835
Pen, 4½" × 6¾".
Drawn by the sixteen-year-old artist on his second visit to the Italian Lakes.
(Courtesy Ashmolean Museum, Oxford)

J. M. W. Turner, *The Chapel of Santa Maria della Spina, Pisa,* 1832
Watercolor, 190 × 173 mm.
Painted by Turner, aged fifty-seven, the year before Ruskin's
first visit to Italy. It was intended as an illustration to an edition
of Byron. The Chapel of La Spina was always a particular
Ruskin favorite. He owned this watercolor vignette, which is
quite reminiscent of the illustrations for *Italy,* having bought it
for fifty guineas, and he presented it to the Ashmolean in 1861.
(Courtesy Ashmolean Museum, Oxford)

John Ruskin, *Piazza di San Marco and Basilica, Venice,* 1835
Pencil on cream paper, 6¾" × 9¾".
Made during Ruskin's first visit to Venice, aged sixteen. It was his avowed intention
"to make such a drawing of the Ducal Palace as never had been made before."
Contrast its four-square stiffness, which reminds one of the style of Samuel Prout,
with the expressive freedom of the later drawings.
(Courtesy Smith College Museum of Art, Northampton, Massachusetts; Gift of Charles E. Goodspeed, 1950)

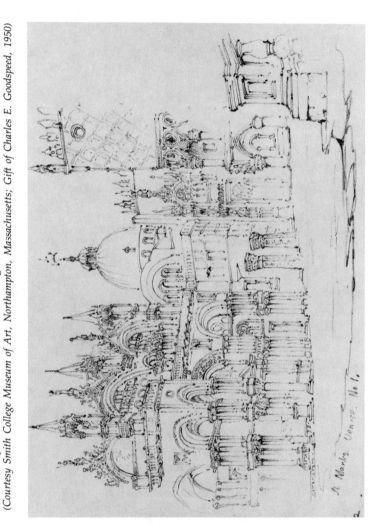

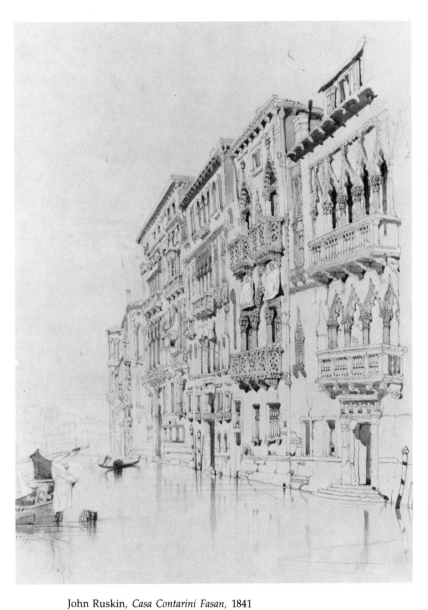

John Ruskin, *Casa Contarini Fasan*, 1841
Pencil and wash, 17¼″ × 12½″.
The Ruskin family was in Venice for eleven days in May 1841.
It was at that time that Ruskin truly became involved in the
city's architecture, and he made two major drawings—one of
the Giants' Staircase in the Doge's Palace, and this one.
(Courtesy Ashmolean Museum, Oxford)

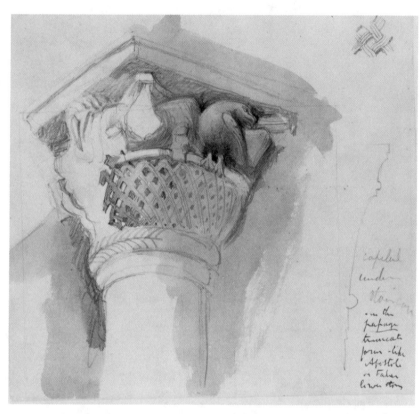

John Ruskin, Capital, ca. 1852
Graphite, grey wash with touches of white gouache on cream
paper, 148 × 165 mm.
This is the sort of sketch, and they were numerous, Ruskin
made for his work on *The Stones of Venice*. It is also what he
was up to at such times as Effie complained, ''John is very busy
in the Doge's Palace all day.''
(Courtesy Fogg Art Museum, Cambridge, Massachusetts)

John Ruskin, Tracery at San Sebastiano, ca. 1850
Pen and wash drawing over pencil on paper.
This shows clearly the use to which Ruskin put his sketches of
this period, in its almost compulsively detailed analysis of
structure. It is easy to see the illustrations for *The Stones of
Venice* emerging from this.
*(Courtesy Smith College Museum of Art, Northampton,
Massachusetts; Gift of Charles E. Goodspeed, 1950)*

John Ruskin, Study of Archivolt in St. Mark's, Venice, ca. 1852
Watercolor, graphite, pen and black ink, gold paint on off-white paper,
383 × 547 mm.
Includes an interesting reference to the use of the daguerreotype. The date is
problematic; possibly as late as 1882. Stylistically, though, the earlier date seems more
convincing. It could, of course, have been inscribed later for presentation.
(*Courtesy Fogg Art Museum, Cambridge, Massachusetts; Gift of Edward W. Forbes*)

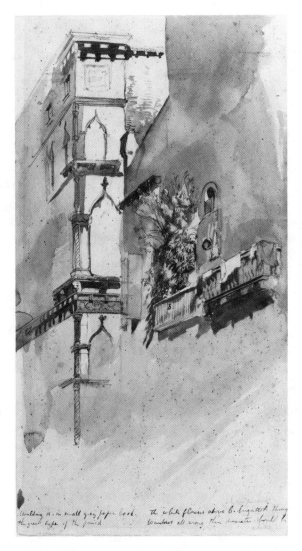

John Ruskin, Architectural Study
Watercolor over graphite, pen and black ink on cream paper,
379 × 199 mm.
No date or location are provided, but this is surely Venice, and
probably from the period of *Stones*. It is a more casual piece,
with charming domestic details, which shows that Ruskin's
interest was not limited to the city's "great" buildings.
*(Courtesy Fogg Art Museum, Cambridge, Massachusetts; Gift of the
Estate of William and Frances White Emerson)*

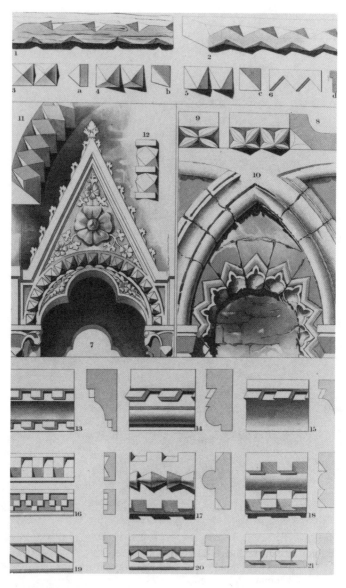

John Ruskin, Illustration (Plate IX) from the First Edition of
The Stones of Venice
Published by Smith, Elder, and Co., London, 1851.
It is interesting to see how on-the-spot sketches were turned
into book illustrations, and to see the fruit of Ruskin's
extraordinary eye for minute detail and exact measurement.

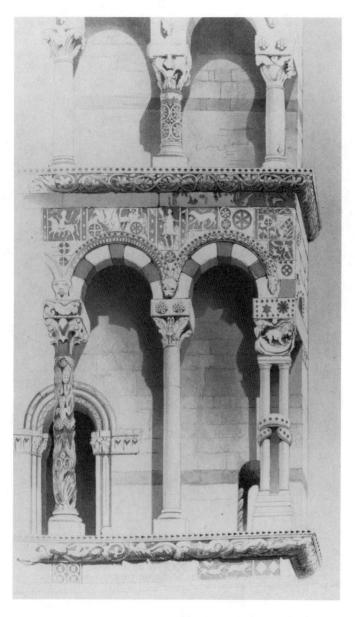

John Ruskin, Illustration (Plate XXI) from the First Edition of
The Stones of Venice
Published by Smith, Elder, and Co., London, 1851.
This illustration, ''Wall-Veil Decoration, San Michele, Lucca,''
can be compared with on-location sketches of the same building.

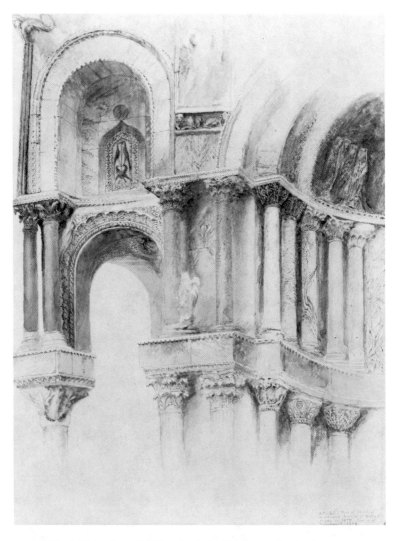

John Ruskin, Part of a Sketch of the Northwest Porch of
St. Mark's, 1879
Watercolor, graphite, white gouache on cream paper,
491 × 352 mm.
As Ruskin himself indicates, this is based on a drawing made
two years earlier, which he was presumably fond enough of to
rework. Ruskin had been in Venice from September 1876 to
May 1877, working on the revised *Stones*.
*(Courtesy Fogg Art Museum, Cambridge, Massachusetts; Gift of
Samuel Sachs)*

John Ruskin, *Venice, View on a Canal*, ca. 1874
Pencil on ivory paper, 11¾₆" × 13⅛".
A striking contrast to the earlier drawings, this sketch is curiously and ironically reminiscent of Whistler's etchings of Venice—the notorious legal entanglement of Ruskin with that artist took place in 1877.
(Courtesy Smith College Museum of Art, Northampton, Massachusetts; Gift of Charles E. Goodspeed, 1950)

John Ruskin, *View of Amalfi,* 1844(?)

Watercolor, gouache over graphite on brown paper, 341 × 493 mm.

One of Ruskin's most immediately appealing view paintings. The 1844 Ruskin foreign tour was to France and Switzerland, and included only a brief excursion onto Italian soil, to Lake Maggiore. Assuming this was done on location and is not a later reworking, the likeliest occasion would have been the journey from Rome to Naples at the beginning of 1841. "Turnerian" is the only word to describe the verve and sweep of this delightful watercolor, but the architectural detail is sharper than one feels Turner would have cared to make it.

(Courtesy Fogg Art Museum, Cambridge, Massachusetts; Gift of Mr. and Mrs. Philip Hofer)

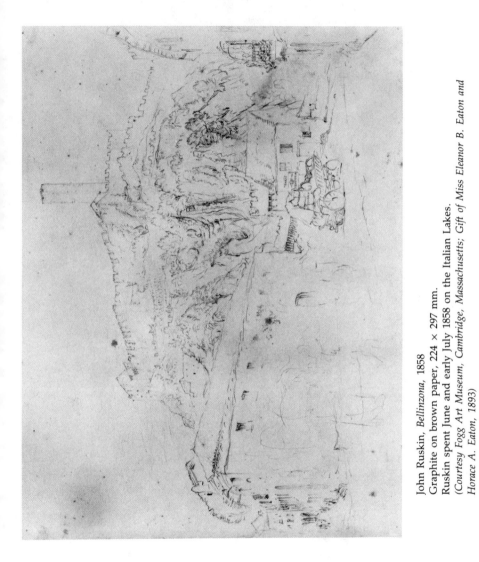

John Ruskin, *Bellinzona*, 1858
Graphite on brown paper, 224 × 297 mm.
Ruskin spent June and early July 1858 on the Italian Lakes.
(Courtesy Fogg Art Museum, Cambridge, Massachusetts; Gift of Miss Eleanor B. Eaton and Horace A. Eaton, 1893)

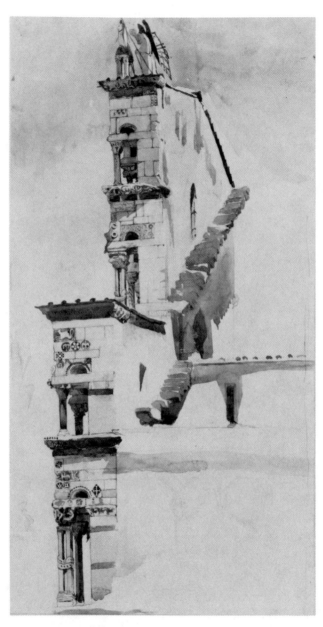

John Ruskin, *Lateral View of San Michele, Lucca,* 1845
Drawn on Ruskin's first visit to Lucca, the town which, more
than any other, turned him towards the study of architecture.
(Courtesy Ashmolean Museum, Oxford)

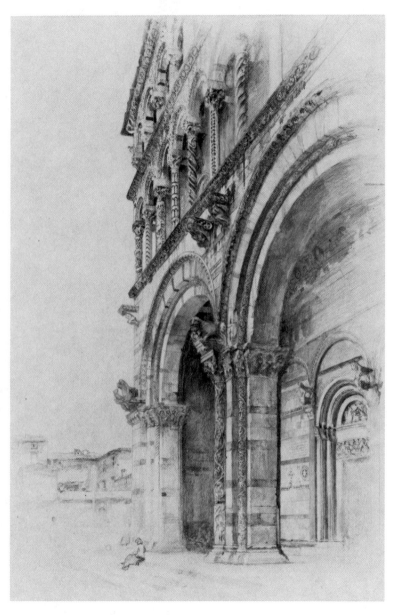

John Ruskin, *San Martino, Lucca,* 1874
The product of a later visit to Lucca, when Ruskin spent some
time there toward the latter part of his 1874 Italian trip after his
lengthy stay at Assisi studying Giotto.
(Courtesy Ashmolean Museum, Oxford)

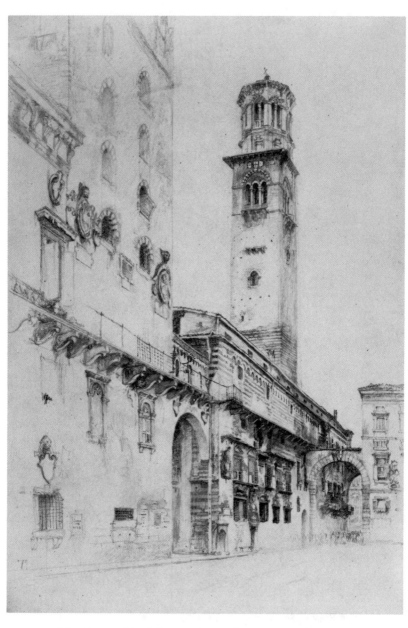

John Ruskin, *Piazza dei Signori, Verona,* 1869
Ruskin arrived in Verona on May 8, 1869, and during his stay
there received the offer of the Slade Professorship.
(Courtesy Ashmolean Museum, Oxford)

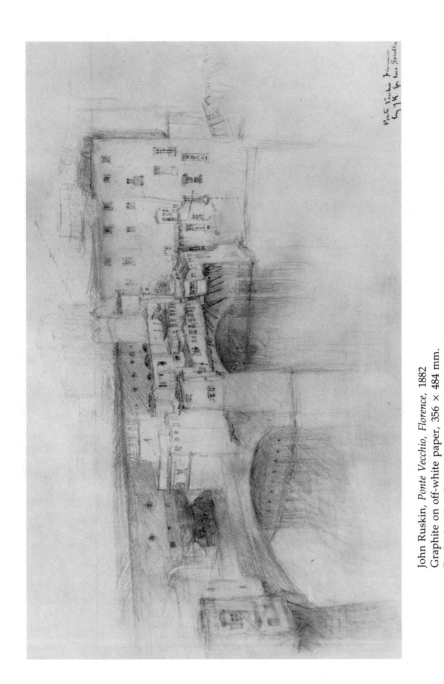

John Ruskin, *Ponte Vecchio, Florence*, 1882
Graphite on off-white paper, 356 × 484 mm.
Ruskin's "Sorella" is Francesca Alexander, whom Ruskin had met earlier in 1882, and
with whom he later collaborated on *Roadside Songs of Tuscany.*
(Courtesy Fogg Art Museum, Cambridge, Massachusetts; Gift of Edward W. Forbes)

John Ruskin, *The Borghese Gardens*, ca. 1870s
Graphite with brown wash on cream paper, 160 × 220 mm.
Pure landscape without architecture is common among Ruskin's Swiss views, but rare
in his Italian work. It is a nice touch that one of the few should come from Rome, as
if Ruskin is driving home his undying contempt for Renaissance architecture by
preferring to draw the city's trees.
(Courtesy Fogg Art Museum, Cambridge, Massachusetts; Gift of Frances L. Hofer)

John Ruskin, *Looking Down from Florence toward Lucca*, 1882
Watercolor and gouache over graphite on blue paper, 287 × 494 mm.
Inscribed to Francesca Alexander, this painting was done on the journey described by
W. G. Collingwood in *Ruskin Relics*.
(Courtesy Fogg Art Museum, Cambridge, Massachusetts; Gift of Edward W. Forbes)

John Ruskin, *Tomb of Ilaria di Caretto, Cathedral, Lucca*
Jacopo della Quercia's work is an odd blend of the International Gothic Style (the figure) and Renaissance decorative notions (the putti and swags). The tomb was one of Ruskin's favorite works of art, from his first discovery of it in 1845 until his last sight of it in 1882.
(Courtesy Ashmolean Museum, Oxford)

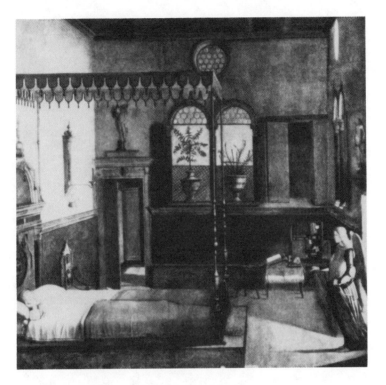

Vittore Carpaccio, *The Dream of St. Ursula*
Accademia, Venice.
The obsession of Ruskin's latter visits to Venice. He devoted
much research to Carpaccio, both for the *Guide to the Academy*
(1877), and for a projected, but never completed, catalogue of
his works. St. Ursula became confused in his mind with the
spirit of Rose La Touche.

Notes

Chapter 1

1. Samuel Rogers, *Italy: A Poem* (Cadell and Moxon), 1830.

2. Ibid., p. iv.

3. Ibid., p. iii.

4. Lady Morgan's *Life and Times of Salvator Rosa* had appeared in 1824.

5. Practically all of Mrs. Radcliffe's villains have Italian names. Many of her novels have Italian settings also: *The Mysteries of Udolpho*, 1794; *The Italian*, 1797; *A Sicilian Romance*, 1790.

6. *The Works of John Ruskin*, edited by E. T. Cook and Alexander Wedderburn, 39 vols. (Allen), 1903–1912, 37.249.

7. *Works*, 1.363.

8. *Works*, 35.295.

9. *Works*, 35.150.

10. *Works*, 10.8.

11. See, for instance, such of Browning's dramatic monologs as "Andrea del Sarto" for more realistic views of Italian life and culture.

12. *Works*, 35.29.

13. *Works*, 35.104. They also visited the battlefield of Waterloo.

Chapter 2

1. *Works*, 35.79.

2. *Works*, 2.345.

3. *Works*, 35.116.

4. Ruskin's first published work, done at the age of fifteen, appeared in *Loudon's Magazine of Natural History*, Sept. 1834. It was entitled "On the Causes of the Colour of the Water of the Rhine." Several other early papers were published in the same place.

5. Gail S. Weinberg, *Drawings of John Ruskin.* Exhibition Catalogue (Fogg Art Museum), 1979. P. 14 has a series of Swiss and Italian views, all done as vignette ovals, all dating from 1833.

6. E. T. Cook, *The Life of Ruskin,* 2 vols. (Macmillan), 1911, I.36.

7. *Works,* 35.117.

8. According to Cook, I.36, they also visited Turin, but Ruskin says nothing of Turin at this point in *Praeterita.*

9. *Works,* 35.80.

10. Joan Evans, *John Ruskin* (Oxford University Press), 1950, p. 36.

11. *Works,* 35.80.

12. *Works,* 35.109.

13. *Works,* 35.81.

14. *Works,* 35.81.

15. Cook, I. 42.

16. *Works,* 35.152.

17. *Works,* 35.156.

18. *Works,* 35.182.

19. Ms. at Princeton. Quoted by J. D. Hunt, *The Wider Sea* (Viking Press), 1982, p. 69.

20. *Works,* 2.208.

21. *Works,* 35.264.

22. *Works,* 35.270.

23. W. G. Collingwood, *Life of John Ruskin,* 2 vols. (Houghton Mifflin), 1893, I.108.

24. Raphael's Vatican frescoes in the Stanza della Segnatura, painted in 1509, may be taken as apt representatives of the Italian High Renaissance style. In the Ruskinian context here they are especially appropriate, in that their theological purpose was to establish a relationship between classical learning and the Christian tradition.

25. *Works,* 35.272.

26. *Works,* 35.283.

27. Derrick Leon, *Ruskin: The Great Victorian* (Routledge and Kegan Paul), 1949, p. 62, especially emphasizes the precarious state of Ruskin's mental health in 1840.

28. *Works,* 35.269.

29. *Works,* 35.295.

30. *Works,* 35.296.

31. *Works,* 35.297.

Chapter 3

1. See Luke Herrmann, *Ruskin and Turner* (Faber and Faber), 1968, pp. 19–22, for a detailed account of Ruskin's early Turner acquisitions.

2. *Works*, 35.380.

3. Cook, I.172.

4. Jacopo della Quercia (ca. 1374–1438), sculptor, born in Siena, a contemporary of Donatello and Ghiberti. The tomb of Ilaria del Caretto is his earliest surviving work, and is a curious blend of Gothic effigy with Renaissance decorative detail.

5. *Ruskin in Italy: Letters to his Parents, 1845*, ed. Harold I. Shapiro (Oxford University Press), 1972, p. 51. This particular reference is to the church of San Frediano.

6. Cook, I.178.

7. Shapiro, p. 61.

8. J. D. Hunt, *The Wider Sea* (Viking Press), 1982, p. 148.

9. *Works*, 4.xxxii. Quotes from a letter to his father, June 4, 1845, expressing his delight in discovering Cimabue, Orcagna, Ghirlandaio, and others.

10. James Jackson Jarves was the first American to collect and write articles promoting early Italian painting. His collection is now at Yale.

11. Cook, I.182.

12. Cook, I.184.

13. Shapiro, p. 211.

14. Cook, I.196.

15. *Works*, 12.289.

16. Cook, I.194.

17. The founder members of the Arundel Society, founded in 1848, were Lord Lindsay, the Marquess of Lansdowne, Lord Herbert of Lea, Samuel Rogers, A. H. Layard, and Ruskin himself. The stated aim of the Society was to preserve and record early painting, chiefly Italian frescoes, and to diffuse knowledge of them in order to elevate the taste of the age.

18. Shapiro, p. 198.

19. Shapiro, p. 201.

20. Shapiro, p. 208.

21. Shapiro, p. 220.

22. Shapiro, p. 50.

23. Shapiro, p. 86.

24. Shapiro, p. 160.

25. Shapiro, p. 208.

26. Especially controversial was the naming of Wiseman as Archbishop of Westminster in 1850.

Chapter 4

1. *The Diaries of John Ruskin*, eds. Joan Evans and J. H. Whitehouse, 3 vols. (Oxford University Press), 1956, I. 326.

2. *Works,* 8.xxiii.

3. *Works,* 35.419.

4. Lord Lindsay, author of *Sketches of the History of Christian Art,* 3 vols., 1847, then the only compendium of information about early Italian painters.

5. J. G. Links, *The Ruskins in Normandy* (John Murray), 1968.

6. *Works,* 24.405.

7. *Works,* 10.xlvii.

8. Mary Lutyens, *Effie in Venice* (John Murray), 1963, pp. 41–62.

9. Lutyens, p. 69.

10. Lutyens, p. 72.

11. Lutyens, p. 77.

12. Lutyens, p. 85.

13. Evans, p. 160.

14. Cook, I.258.

15. Lutyens, p. 90.

16. Lutyens, p. 95.

17. Lutyens, p. 107.

18. Lutyens, p. 155.

19. *Ruskin's Letters from Venice, 1851–52,* ed. J. L. Bradley (Yale University Press), 1955, p. 26.

20. Cook, I.268.

21. Bradley, p. 21.

22. Lutyens, p. 192.

23. Collected in *Golden Codgers,* ''Overtures to *Salomé''* (Oxford University Press), 1973.

24. Lutyens, p. 224.

25. Lutyens, p. 225.

26. Bradley, p. 35.

27. Lutyens, p. 225. Letter owned by Mr. Nigel Capel Cure.

28. Bradley, p. 35.

29. See John Steegman's *Consort of Taste* (Sidgwick and Jackson), 1950, on this subject.

30. *Works,* 35.504.

Chapter 5

1. See ''Iron'' in *The Two Paths,* for Ruskin on Bellinzona.

2. *Diaries,* II.536.

3. *John Ruskin: Letters from the Continent, 1858,* ed. John Hayman (University of Toronto Press), 1982, p. 87.

4. Cook, I.521.

5. See George Landow, *The Aesthetic and Critical Theories of John Ruskin* (Princeton University Press), 1971.

6. *Works*, 29.87–91.

7. Paolo Veronese, (ca. 1528–1588) is generally thought to be the culmination of the Venetian colorist tradition. Appropriately, given the dichotomy in artistic temperaments here being considered, he was called before the Inquisition to answer charges of heresy.

8. *Works*, 7.xli.

9. See letter to the Brownings, *Works*, 36.275–276, 279–280.

10. *Fors Clavigera*, Letter 76. *Works*, 29.87.

11. *Works*, 35.495.

12. *Works*, 29.87.

13. *Diaries*, II.537.

14. Hayman, *Letters from the Continent*.

15. Hayman, pp. 115–16.

16. *Letters of John Ruskin to Charles Eliot Norton*, 2 vols. (Houghton Mifflin), 1904, I.65.

17. Ruskin and Rossetti became friends when Ruskin wrote his pamphlet in defense of the newly appeared Pre-Raphaelite painters. Ruskin gave Rossetti much support, both professional and financial, for many years.

18. For Ruskin on Luini, see *Works*, 19.lxxiii–lxxv.

19. *Norton* letters, I.128.

20. *Reflections of a Friendship: John Ruskin's Letters to Pauline Trevelyan, 1848–1866*, ed. Virginia Surtees (George Allen and Unwin), 1979.

21. Ruskin's contribution to the decorative scheme was a painting of wheat.

22. Surtees, p. 224.

23. *Works*, 36.440.

24. Surtees, p. 255.

Chapter 6

1. Cook, II.18.

2. *Works*, 14.351. Letter concerning Burgess.

3. Cook, II.159.

4. Cook, II.162.

5. Cook, II.160.

6. Vittore Carpaccio (active 1490–1523). Venetian painter whose high nineteenth-century reputation, since declined, was largely due to Ruskin's fondness for him. Best known for various cycles from lives of saints, including those of St. Ursula. Valued mainly for his narrative and anecdotal gifts.

7. Cook, II.159.

8. Evans, p. 308.

9. *Diaries*, II.668–69.

10. *Works*, 37.6.

11. *Works*, 27.328.

12. Cook, II.229.

13. Cook, II.229.

14. Sandro Botticelli (1445–1510). In terms of Ruskin's waverings between "pure" and "fleshly" ideas, Botticelli represented a reaction against the growing naturalism of Masaccio and others, with his preference for the flat spaces and decorative line of the International Gothic Style. In this context his reputed connection with Savonarola may be relevant. His reputation was low until a major rehabilitation in the mid-nineteenth century, to which Ruskin, as well as Pater and the Pre-Raphaelites, contributed.

15. Cook, II.232.

16. *Works*, 37.52.

17. *The Professor: Arthur Severn's Memoir of John Ruskin*, ed. James S. Dearden (George Allen and Unwin), 1967.

18. *The Professor*, p. 51.

19. *The Professor*, p. 55.

20. *The Professor*, p. 61.

21. Cook, II.244.

22. Cook, II.245.

23. Giotto (ca. 1267–1337) represents another phase in Ruskin's taste for the "pure" and religious in art, and his frescoes in Assisi's San Francesco, the authenticity of which has been questioned by twentieth-century scholarship, show him at his most obviously devotional.

24. *Diaries*, III.784.

25. Cook, II.246.

26. Cook, II.248.

27. Letter 46. *Works*, 28.171.

28. Letter to Susan Beever, April 14, 1874, Cook II.249.

29. "Ruskin as I Knew Him," by Sir William Richmond, *St. George*, vol. v. p. 297.

30. Evans, p. 348.

31. *Diaries*, III.796.

32. *Works*, 29.91.

33. Cook, II.254.

34. *Diaries*, III.793–800.

35. "Recollections of Ruskin," by Oscar Browning, *St. George*, vol. vi. p. 142.

36. *Works*, 26.225.

37. *Diaries*, III.801.

38. Cook, II.270.

Chapter 7

1. See J. S. Dearden's Essay "John Ruskin and Prince Leopold" in *Facets of Ruskin: Some Sesquicentennial Studies*, ed. James S. Dearden (Charles Skilton), 1970.

2. Cook, II.294.

3. Cook, II.298.

4. These two young artists, with Count Zorzi, have the distinction of being just about the only Italians Ruskin ever became friendly with.

5. Cook, II.300.

6. Robert Hewison, *Ruskin and Venice* (Thames and Hudson), 1978, p. 95.

7. Collingwood, II.463.

8. Letter to Joan Severn, Cook, II.296.

9. Cook, II.302.

10. In an article on "Venice," *Century Magazine*, Nov. 1882.

11. E. T. Cook, *Studies in Ruskin*, p. 244.

12. *Works*, 24.163, 24.179.

13. Proust, a lifelong Ruskinian, chose this work to translate into French.

14. *Diaries*, III.1028.

15. *Ruskin Relics*, 1903, pp. 47–104.

16. *Diaries*, III.1029.

17. Cook, II.464.

18. Weinberg, *Catalogue*, p. 32.

19. Leon, p. 558.

20. *Diaries*, III.1150.

21. Cook, II.527.

22. Cook, II.527.

23. *The Gulf of Years*, ed. Rayner Unwin (George Allen and Unwin), 1953.

Bibliography

No attempt is made to give an exhaustive bibliography. The works listed here are those specifically relevant to the subject of Ruskin and Italy, and all were valuable in the preparation of the present study.

Bell, Quentin. *Ruskin*. George Braziller, 1973.
Birkenhead, Sheila, Lady. *Illustrious Friends*. Reynal and Co., 1965.
Bradley, John Lewis. *Ruskin's Letters from Venice, 1851–52*. Yale University Press, 1955.
_____. *An Introduction to Ruskin*. Houghton Mifflin, 1971.
Burd, Van Akin. *The Winnington Letters*. Harvard University Press, 1969.
_____. *The Ruskin Family Letters*, 2 vols. Cornell University Press, 1973.
Chandler, Alice. *A Dream of Order*. Routledge and Kegan Paul, 1971.
Churchill, Kenneth. *Italy and English Literature, 1764–1930*. Barnes and Noble, 1980.
Clark, Kenneth, Lord. *Ruskin Today*. Penguin Books, 1964.
Clegg, Jeanne. *Ruskin and Venice*. Junction Books, 1981.
Collingwood, W. G. *The Life and Work of John Ruskin*, 2 vols. Houghton Mifflin, 1893.
_____. *Ruskin Relics*. Isbister, 1903.
Cook, E. T. *The Life of John Ruskin*, 2 vols. Macmillan, 1911.
Dearden, James S., ed. *The Professor: Arthur Severn's Memoir of John Ruskin*. George Allen and Unwin, 1967.
_____. *Facets of Ruskin: Some Sesquicentennial Studies*. Charles Skilton, 1970.
Evans, Joan. *John Ruskin*. Oxford University Press, 1950.
_____, and Whitehouse, J. H. (eds.) *The Diaries of John Ruskin*, 3 vols. Oxford University Press, 1955–59.
Fishman, Solomon. *The Interpretation of Art*. University of California Press, 1973.
Garrigan, Kristine Ottesen. *Ruskin on Architecture*. University of Wisconsin Press, 1973.
Gurewitsch, Susan. "Golgonooza on the Grand Canal: Ruskin's *Stones of Venice* and the Romantic Imagination." *Arnoldian*, 9, i, pp. 25–39.
Hamilton, Olive. *Paradise of Exiles: Tuscany and the British*. Andre Deutsch, 1974.
Hayman, John (ed.) *John Ruskin: Letters from the Continent, 1858*. University of Toronto Press, 1982.
Helsinger, Elizabeth. *Ruskin and the Art of the Beholder*. Harvard University Press, 1982.
Herrmann, Luke. *Ruskin and Turner*. Faber and Faber, 1968.
Hewison, Robert. *The Argument of the Eye*. Thames and Hudson, 1976.
_____. *Ruskin and Venice*. Thames and Hudson, 1978.
Hilton, Tim. *John Ruskin: The Early Years*. Yale University Press, 1985.
Hough, Graham. *The Last Romantics*. Duckworth, 1947.
Hunt, John Dixon. *The Wider Sea: A Life of John Ruskin*. Viking Press, 1982.

James, Sir William. *The Order of Release.* John Murray, 1947.

Leon, Derrick. *Ruskin: The Great Victorian.* Routledge and Kegan Paul, 1949.

Lutyens, Mary. *Effie in Venice.* John Murray, 1963.

———. *Millais and the Ruskins.* John Murray, 1967.

———. *The Ruskins and the Grays.* Vanguard Press, 1972.

Norton, Charles Eliot, (ed.) *Letters of John Ruskin to Charles Eliot Norton,* 2 vols. Houghton Mifflin, 1904.

Quennell, Peter. *John Ruskin: The Portrait of a Prophet.* Collins, 1949.

Rosenberg, John D. *The Darkening Glass: A Portrait of Ruskin's Genius.* Columbia University Press, 1961.

Shapiro, Harold, (ed.) *Ruskin in Italy: Letters to His Parents, 1845.* Oxford University Press, 1972.

Steegman, John. *Consort of Taste.* Sidgwick and Jackson, 1950.

Surtees, Virginia. *Reflections of a Friendship.* George Allen and Unwin, 1979.

Swett, Lucia Gray. *John Ruskin's Letters to Francesca and Memoirs of the Alexanders.* Lothrop, Lee and Shepard, 1931.

Townsend, Francis G. "John Ruskin" in *Victorian Prose: A Guide to Research,* ed. David DeLaura. Modern Languages Association of America, 1973.

Treves, Giuliana Artom. *The Golden Ring: The Anglo-Florentines, 1847-62.* Longmans, Green and Co., 1956.

Unwin, Rayner. *The Gulf of Years.* George Allen and Unwin, 1953.

Viljoen, Helen. *Ruskin's Scottish Heritage.* University of Illinois Press, 1956.

———. *The Brantwood Diary of John Ruskin.* Yale University Press, 1971.

Weinberg, Gail S. *Drawings of John Ruskin.* Exhibition Catalogue. Fogg Art Museum, 1979.

Whitehouse, J. Howard. *Ruskin and Brantwood.* Cambridge University Press, 1937.

———. *Vindication of Ruskin.* George Allen and Unwin, 1950.

Wilenski, R. H. *John Ruskin.* F. A. Stokes, 1933.

Index